GAME
ART

GAME ART

ART FROM 40 VIDEO GAMES AND
INTERVIEWS WITH THEIR CREATORS

MATT SAINSBURY

NO STARCH PRESS

SAN FRANCISCO

Printed in China

19 18 17 16 15 1 2 3 4 5 6 7 8 9

ISBN-10: 1-59327-665-6
ISBN-13: 978-1-59327-665-2

Publisher: William Pollock
Production Editor: Serena Yang
Cover and Interior Design: Beth Middleworth
Developmental Editors: Hayley Baker, Jennifer Griffith-Delgado, and Tyler Ortman
Copyeditor: Paula L. Fleming
Proofreader: Emelie Burnette

For information on distribution, translations, or bulk sales, please contact No Starch Press, Inc. directly:

No Starch Press, Inc.
245 8th Street, San Francisco, CA 94103
phone: 415.863.9900
info@nostarch.com; http://www.nostarch.com/

Library of Congress Cataloging-in-Publication Data
Sainsbury, Matt.
 Game art : art from 40 video games and interviews with their creators / by Matt Sainsbury.
-- 1st edition.
 pages cm
 Summary: "Features interviews with game developers and discussion of the creative process behind video game development. Includes full-color artwork and concept art from 40 video games"-- Provided by publisher.
 ISBN 978-1-59327-665-2 -- ISBN 1-59327-665-6
 1. Video games--Design. 2. Video games industry. 3. Art. I. Title.
 GV1469.3.S148 2015
 794.8--dc23

 2015013186

ACKNOWLEDGMENTS

There are too many people I'd like to thank for their help and support in making this book a reality.

I'd like to thank No Starch Press for seeing the potential in it; my friends and team at DigitallyDownloaded.net for their feedback and support; and, of course, my family for the way they have always been able to encourage me. Thanks to all the wonderful developers in this book who agreed to be interviewed and share their amazing art.

But most of all, I'd like to thank my wife. Putting up with me isn't always easy, and without her saintly patience and support, I would have never followed my dream to write about games and this book would never have happened.

CONTENTS

FOREWORD . viii
by Larry Goldberg, COO of E-Line Media

PREFACE . x

BEAUTIFUL GAMES
SERENITY AND WONDER 004
Tengami (Nyamyam)
Jennifer Schneidereit, co-founder

TELLING A STORY . 014
Bientôt l'été, Luxuria Superbia, The Graveyard,
The Path, Sunset (Tale of Tales)
Auriea Harvey and Michaël Samyn, owners

ESCAPE TO THE SHADOWS 024
Contrast (Compulsion Games)
Guillaume Provost, creative director

THE SUPERNATURAL
AND THE SURREAL
TURNING TRAGEDY
INTO HORROR . 036
Deception IV, Fatal Frame II (Koei Tecmo Games)
Keisuke Kikuchi, producer

PLAYING DETECTIVE 046
D4: Dark Dreams Don't Die (Access Games)
Hidetaka Suehiro, director

FANTASY WORLDS
INDIE FREEDOM IN A
TRIPLE-A STUDIO . 056
Child of Light (Ubisoft Montreal)
Jean-François Poirier, producer

RISING FROM THE ASHES 070
Final Fantasy XIV: A Realm Reborn (Square Enix)
Naoki Yoshida, director and producer

UNCHARTED TERRITORY 088
Dragon Age: Inquisition (Bioware)
Mike Laidlaw, creative director

PUSHING BOUNDARIES
IDEALIZED FIGHTERS AND
STYLIZED VIOLENCE 104
Dead or Alive 5, Ninja Gaiden 3 (Koei Tecmo Games)
Yosuke Hayashi, director and producer

SEX AND VIOLENCE 114
KILLER IS DEAD, LOLLIPOP CHAINSAW,
Shadows of the DAMNED (Grasshopper Manufacture)
Goichi Suda, CEO

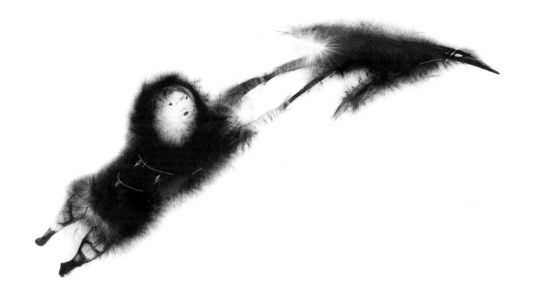

EPIC QUESTS AND EVERYDAY LIFE
PARODY WITH
CUTE CHARACTERS 128
Fairy Fencer F, *Hyperdimension Neptunia* (Idea Factory),
Naoko Mizuno, producer, and Tsunako, character designer

BUILDING NEW WORLDS 142
Arland and *Dusk* trilogies,
from the *Atelier* series (Koei Tecmo Games)
Yoshito Okamura, series director

LAUGHTER AND ABSURDITY 154
Monster Monpiece, *Sorcery Saga:*
Curse of the Great Curry God (Idea Factory)
Makoto Kitano, artist and designer

MICROBUDGET GAMES
ROOTS IN FILM.......................... 166
NaissanceE (Limasse Five)
Mavros Sedeño, creator and owner

CREATIVITY UNDER
CONSTRAINT 178
flowmo (ToyBox Labs)
Peter Budziszewski and Tamara Schembri, owners

CHEERFUL COLOR AND
SIMPLE GAMEPLAY 186
escapeVektor, *Spirit Hunters Inc* (Nnooo)
Nic Watt, creative director and founder

CULTURE AND HISTORY
REPRESENTING
NATIVE CULTURES......................... 196
Never Alone (E-Line Media)
Amy Fredeen, CFO, and Alan Gershenfeld, founder

REMIXING HISTORY..................... 210
Bladestorm: Nightmare, *Dynasty Warriors*,
Samurai Warriors (Koei Tecmo Games)
Akihiro Suzuki, series director and producer of *Dynasty Warriors*,
and Hisashi Koinuma, director and producer of *Samurai Warriors*

CHILDHOOD INFLUENCES
TWISTED FAIRY TALES 230
Akaneiro: Demon Hunters (Spicy Horse),
Alice: Madness Returns, *American McGee's Alice* (EA)
American McGee, managing director of Spicy Horse

BRINGING CHILDHOOD
FANTASIES TO LIFE 242
Gamebook Adventures (Tin Man Games)
Neil Rennison, creator and owner

A GAME THAT NEVER ENDS 252
Malevolence: The Sword of Ahkranox (Visual Outbreak)
Alex Norton, creator and owner

FOREWORD

I would like to thank Matt Sainsbury for taking the time to investigate in depth the evolution and advancement of video games as an art form. Understanding what motivates others to expand the boundaries of entertainment through interactivity is a subject worthy of exploration.

Well-designed games have the ability to deeply engage an audience in ways no other medium can, and there is a very good reason why hundreds of millions of people of all ages, genders, races, and nationalities play them. Not only do video games provide a complete visual and audio experience that rivals any other form of art, they also put players at the center of the action with the ability to control what happens.

The video game business has developed rapidly over the past 30 years, unleashing a surge of creativity, vision, and aesthetics that is almost hard to fathom. When else has a form of recreation delivered such a diverse and comprehensive variety of highly captivating experiences in such a short period of time? Since its inception, the gaming industry has allowed us to embark on epic adventures, build civilizations, explore the universe, and play as world-class athletes. Over billions of hours, so many minds have been challenged to solve complex puzzles, manage scarce resources, and strategize the best approach to advance through incredible worlds.

It is very difficult, if not impossible, for me to name every advancement in video game making

that has blown me away over the years, but several stick with me. I still recall the first time a game controller became a natural and seamless extension of my will. I remember when a sudden shift from darkness to brightness, coupled with the propulsion of a shrieking monster from the depths, scared the living daylights out of me. I marveled when the Internet allowed me to be alone at home, yet deeply connected to others in my gaming adventures. I couldn't believe that large numbers of characters could know exactly what to do without being controlled by players. And my mouth still drops in awe every time I play a racing or sports game and the cars or players are so detailed that everything feels real.

Equally impressive is the vast array of emotions and mental states that games can elicit: from surprise to elation, suspense to laughter, camaraderie to isolation, frustration to accomplishment, and of course, sadness to intense joy! Players are active participants in video games, and so these emotions are often deeper, stronger, and more satisfying than those found in more passive entertainment.

When I ran the worldwide studios at Activision in the early 2000s, I was fortunate enough to contribute to some of gaming's best-known franchises (*Tony Hawk's Pro Skateboard*, *Call of Duty*, and *Spider-Man* to name just a few) and help in a small way to move the art of game making forward. Being involved with these games, working with the incredible teams that made them, and knowing that millions have

been able to enjoy and react to these products has given me a great sense of pride and satisfaction.

Over the past two decades, I have had the distinct pleasure and honor of getting to know several of the most talented people in the business, and all of them possess a remarkable level of ingenuity and passion. Making a great game also requires diverse skills (game design, art, engineering, and leadership), and so the inspiration for some of the best games has come from many types of people around the world who often possess expertise in very different disciplines. This no doubt has helped lead to the incredible breadth of great games released over the years.

There is tremendous opportunity to bring even more new voices and perspectives to the digital gaming medium. To this end, a few years ago I was lucky enough to join E-Line Media and help create the most inspirational and motivational work of my career: a puzzle platform game called *Never Alone* (Kisima Innitchuna). E-Line's game development team worked with over 40 Alaska Native storytellers and elders to create a game that delves deeply into the traditional lore and culture of the Inupiat people of the Arctic slope. Based on the reaction of gamers and critics alike, *Never Alone* has struck a unique chord by examining values such as resiliency and interdependence. It is not just game about the Alaska Native culture; it is a game made with the Alaska Native culture.

I hope to participate in and expand upon the industry's ability to work closely with and draw fully on the richness of unique cultures to create complex and fascinating games for global audiences for years to come. There are many cultures around the world with compelling traditions and folklore, and making "world games," as E-Line calls them, is a great method for bringing different ways of life and perspectives to people who might not otherwise experience them. This is just one frontier in the video game landscape, and it's a fantastic opportunity to show just how games can be used to investigate the world we live in and the emotions we all feel. I look forward to seeing what comes next from both veteran game makers and new pioneers who are waiting in the wings with fresh ideas and insights. I know they will continue to drive the medium forward in an exciting fashion.

As the art, technology, and design of games continues to advance, we will harness the power of interactivity to explore the human condition in new manners. We will be able to allow people to tackle themes and express themselves in ways unimaginable in past generations. But we are still in the early days of this new art form, and there is so much more to come.

I, for one, can't wait to see what's next.

Larry Goldberg
Chief Operating Officer of E-Line Media
Los Angeles, California
April 2015

PREFACE
GAMES ARE ART

In interviews, game developers are so often asked about the newest, coolest features in their games that they rarely have an opportunity to talk about themselves, what drives their work, and the themes they consider important as artists. But video games are a creative outlet, and increasingly, game designers use their work to express very personal messages.

Given that trend, this book does not argue that video games are art. It simply accepts this as fact, goes straight to the developers, and allows them to talk. You'll certainly find beautiful art here, but this book isn't just about the visual side of games, either. It's about ideas, and how individual game developers express their ideas.

Games are beautiful. Games are a dance, set to a carefully orchestrated soundtrack. Games are a vehicle for change. And like all works of art, games have meaning far beyond the entertainment they provide.

My hope is that after reading this book, you'll be inspired to look deeper into the games you play—whether they are created by one person or a team of hundreds—and consider the broader message that even seemingly super-ficial games might have.

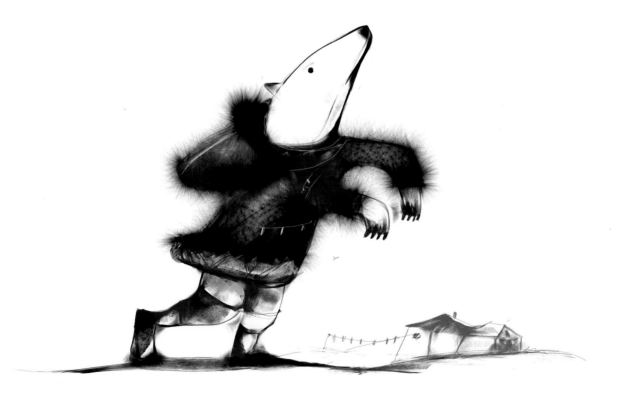

BEAUTIFUL

GAMES

SERENITY AND WONDER

Jennifer Schneidereit, cofounder at independent developer Nyamyam, designed and released *Tengami* as her first independent game. *Tengami* is a point-and-click adventure, but its papercraft art style and push-and-pull puzzles mimic a pop-up picture book. Schneidereit, an industry veteran, and cofounder Phil Tossell quit their steady jobs to become

Previous page: In-game art from Tengami (Ryo Agarie)
Above: Promotional art for Tengami (Ryo Agarie)

JENNIFER
SCHNEIDEREIT
STUDIO: NYAMYAM
LOCATION: GERMANY
FEATURED GAME:
TENGAMI

independent developers in 2010. Their inspiration is simple: "Phil was watching a pop-up book animation, which some students had done as a university project, and we started to talk about how we'd liked pop-up books as children because they gave us a sense of wonder as we were turning the page," Schneidereit said.

"You didn't really know why it was possible for folded paper to create such intricate scenes, and that's a beautiful thing. We were wondering why something so interesting and beautiful as a pop-up book had not been used as the basis for video games before. Then we got to thinking about what kind of video games could be developed that used pop-up as a mechanic and setting."

Pop-up books inspired Schneidereit, but she felt it was important that *Tengami* not be childish, so she and her team searched for the perfect paper texture first. This unusual first step in game development may seem obsessive, but achieving the right look was necessary. In their search for the right look, the team started by scanning dozens of brightly colored, patterned origami paper samples.

"It looked beautiful—but in a very obvious and loud way," Schneidereit said. "We didn't want our game to be a typical happy, brightly colored pop-up book for kids. We wanted to create a very quiet, contemplative tone, and so we wanted something more sophisticated to fit that concept.

"We kept experimenting, and eventually we found some paper where you can sometimes see the imperfections in the surface. While the paper was very minimalist, it was also very striking, and it drew us in. It was calming and contemplative and had all of the elements that we were looking for."

A SELF-PACED ADVENTURE

With the paper texture chosen, the team began designing the mechanics.

"Initially, we did a lot of experiments with the moment-to-moment gameplay with a pop-up book in mind. At first, we were actually thinking about a faster-paced game. We had a character who was jumping and running along, and players would make paths for this character by manipulating the book to open and close platforms," Schneidereit said.

"We spent a long time prototyping bits of that. But at some point, we sat down to analyze it, and we felt that approach didn't really play to the strengths of the pop-up book. The idea there is that a person spends time with this beautiful book and takes their time to turn pages and contemplate what they're seeing. So we scrapped all that we'd just done because it wasn't creating the feeling we wanted. We had to go back to step one and look at it all over again."

The second time around, the game took form.

It would be released as *Tengami*: a serene adventure game that invites players to explore the world in their own time, rather than being pushed through with no time to think. Its tranquil atmosphere also reflects the reverence that the Japanese have for origami, which Schneidereit worked hard to capture authentically in the gameplay. The powerful emotions and spirituality behind Japanese papercraft can be best summarized in the story of one little girl.

When America bombed Hiroshima and Nagasaki to end World War II, the resulting nuclear radiation made many people sick, including Sadako Sasaki, who was two years old when the bombs fell. Sasaki was diagnosed with leukemia at age 12, and from her hospital bed, she was inspired by a legend. According to this legend, if you fold 1,000 origami cranes, thus exhibiting the loyalty and dedication that cranes are known for, you'll prove your worth of having a wish granted. And so Sasaki folded cranes—while praying for world peace.

She died before reaching 1,000 cranes, but in tribute, her classmates folded the rest, and she was buried with the full thousand. A plaque at the base of her grave reads, "This is our cry. This is our prayer. Peace in the world."

Thus, origami is about patience, reflection, and single-minded focus, and Schneidereit said her team realized that making *Tengami* fast-paced or complex would never have done the art form justice.

EAST MEETS WEST

Schneidereit has developed games at both Japanese and Western studios. Born and raised in Germany, she started her career at Acquire, a prolific Japanese studio where she worked on the stealth title *Shinobido: Way of the Ninja* as well as the open-world adventure *Way of the Samurai 3*. After leaving Acquire, Schneidereit also left Japan, moving to the UK to work with Rare on *Kinect Sports* before she and Phil Tossell started their own independent studio. From her experience, she's gained perspective on the two cultures.

Following page: Concept art from Tengami (Nyamyam)

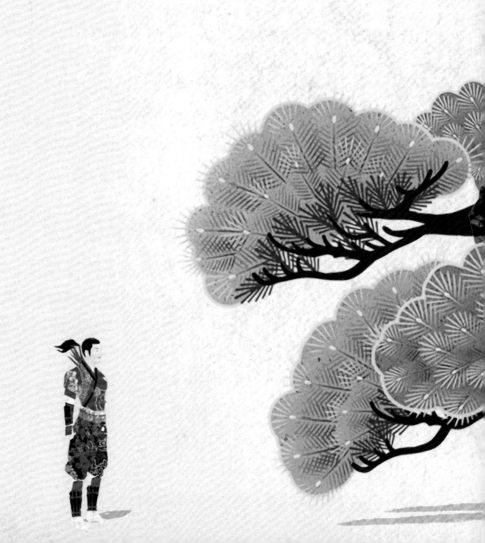

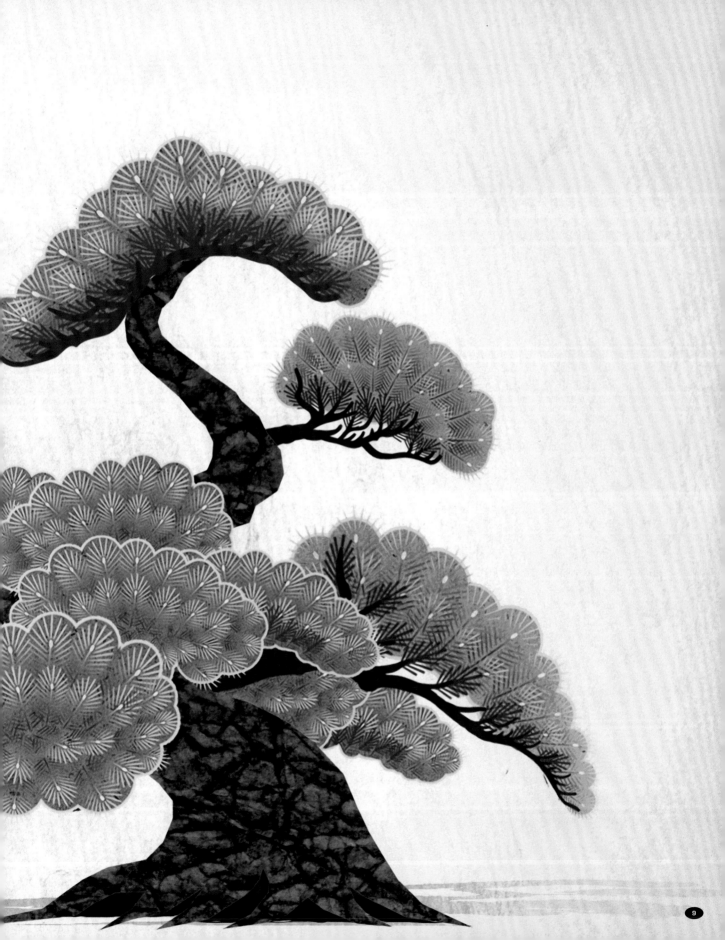

"In Japan, people are a lot more joyful about being game designers. Within their games, they focus on the little jokes and little moments, whereas in the West, game development is more about the overarching story and the big reveal. At the moment, the Western game business model is more commercially successful for the same reason that Hollywood is: it focuses on those big moments because it's much more difficult for the audience to appreciate the little moments.

"Now, I'm trying to combine what I learned about both industries—to include little moments while not losing sight of the bigger picture. It can be tricky. If you get too much in love with each little moment, then it becomes very hard to make a cohesive overall experience in the end."

In-game art from Tengami (Ryo Agarie)

Concept art from Tengami (Nyamyam)

Schneidereit's early affinity for Japanese culture came through exposure to video games. She said, "In the '90s, I was a fan of *Tenchu*, a ninja action game that Acquire made. Older games like *Tenchu* actually sparked new interests for me. I didn't know anything about Japanese culture and history when I played it, so I read books about them, and that's what made me want to live in Japan."

WHY TAKE A RISK?

Schneidereit took a financial risk to break away from the studio system, but she's always wanted creative freedom.

"I had a good time with the big studios, but there's a lot of compromise and politics involved in making games for them," she said. "I do still get the triple-A bug, and it makes me think I can create a new universe that's

better than anything else. But to do that, you either need to start up a triple-A developer from scratch or join an existing one.

"After I worked on *Kinect Sports*, it was clear that Rare would only be making *Kinect Sports* games for the foreseeable future, and sequels are a bit boring. That was when Phil and I started to talk about whether it really would be so difficult or risky to set up our own studio and use our savings to create an interesting, well-made game."

Beyond the creative freedom, Schneidereit also said she was drawn to independent development by her increasing frustration with how straightforward modern blockbuster games are. Of course, many other games draw on history, cultural traditions, and mythology too, but they tend to just show players these elements, rather than let players discover, investigate, and interpret what they see for themselves. *Tengami* is inspired by ancient Japanese artistic traditions, but the references aren't obvious.

"Look at the evolution of the *Tomb Raider* franchise," she said. "The original was filled with references to Greek mythology that the game itself never explained. You didn't have to be a mythology buff to enjoy the game, but to fully understand the game's background and context, you had to do some research. When you did that research, you appreciated the context of the game all the more. Contrast this with the more recent *Tomb Raider* reboot, which left no such mysteries to uncover, and I find these modern popular games don't inspire my imagination quite as much."

And she isn't holding out hope for a change.

"Games are too explicit and bite-sized now. They *tell* you everything that you need to know to enjoy the game to the fullest, and people expect that now. That makes it hard for me to get into modern games."

Opposite: Promotional art for Tengami (Ryo Agarie)

TELLING A STORY

Auriea Harvey and Michaël Samyn, owner-operators of the independent games studio Tale of Tales, have given themselves a unique job title: Purveyors of Beauty and Joy. Consistent with that unusual moniker, they can claim one of the most eclectic game portfolios in the industry. *The Graveyard* is a simple but moving reflection on

In-game art from Luxuria Superbia (Tale of Tales)

AURIEA HARVEY AND
MICHAËL SAMYN
STUDIO: TALE OF TALES
LOCATION: BELGIUM
FEATURED GAMES:
BIENTÔT L'ÉTÉ, THE
GRAVEYARD, LUXURIA
SUPERBIA, THE PATH,
SUNSET

life and death, while *Bientôt l'été*, an homage to the work of French writer and filmmaker Marguerite Duras, investigates the nature of communication between players in games. *Luxuria Superbia* is yet again completely different, a game that's all about sensual pleasure.

But all their games reflect their distinctive conception of their job.

"We want to make beautiful things, and we want that beauty to be accessible to people. We want to take down as many barriers as possible," Samyn said.

"There are different ways to represent beauty. Some are about visuals, some are about audio, and still others are about presenting emotion. But beauty has always been our core concept, and that's why we don't want

objects to shoot or enemies to jump on in our games. Those things are obstacles that get in the way of beauty."

ASKING NEW QUESTIONS

Harvey and Samyn began their careers building websites. Then, growing tired of that work, they started to look for other opportunities to bring their idea of beauty to interactive media.

"We decided to make video games, and we wanted to make something for that audience that was both artistic and inter-active," Harvey said. "We thought, 'Our websites are interactive, and websites can be art, so how hard can making games be?' We didn't really have a plan, just a notion that there was lots of potential there.

"When we play games, we often ask a lot of questions that we don't really have answers to. Why are games so similar to each other? Why do they fit into these neat genres, and why isn't there more variety when video games themselves are great environments for a varied spectrum of content?

"We got a research grant to explore those questions. For two years, we researched game design. We went to conferences and spoke to a lot of developers, then made game prototypes and tested them. At first, there was no answer; it seemed that was just how games were. But now, people are looking for answers."

AGAINST THE TREND

Samyn and Harvey aren't afraid to push boundaries and explore politically or socially sensitive material in their search for answers. *Sunset*, for instance, is a first-person exploration game set in a luxury penthouse within an authoritarian nation. It puts you in the role of a housekeeper who can't resist poking around in her employer's belongings. Eventually, you uncover a rebellion against your country's dictator, and as you learn more, the game lets you experience events that challenge your political beliefs and your attitudes toward wealth and power.

These purveyors of beauty and joy challenge norms in other ways, too, even as players. For example, Samyn once

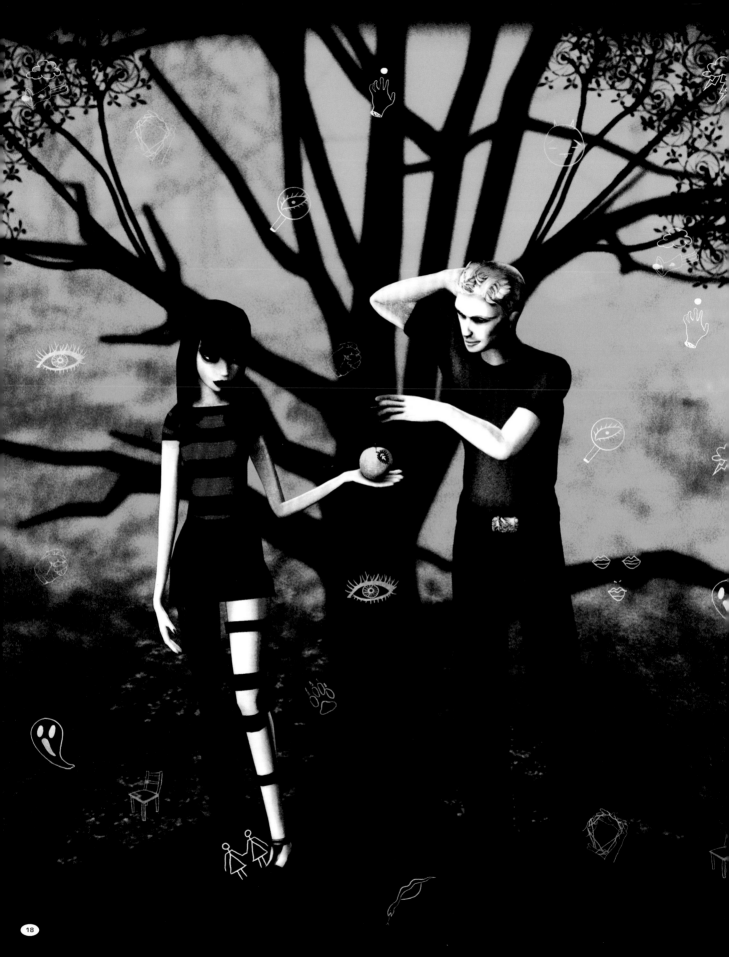

made a New Year's resolution not to kill any virtual creatures for an entire year, a true challenge for someone who plays games as much as he does. He managed to keep the resolution—but it was tough. The industry tends to put forth a relatively narrow range of game experiences, and when you want experiences outside that range, your options are limited.

"The industry has this mantra that it wants to make games for gamers, and it doesn't really care about anyone else," Samyn said. "The group of people playing games has become bigger, but it's still very much isolated from the rest of the world because either you play games or you don't. This has frustrated us since we began making games. We always said we wanted to make games for people who don't play games, and now the industry is so extreme that at times, it feels like if we do that, no one will play our games at all."

The predicament that developers such as Tale of Tales face, Harvey suggested, is not that their games are too complicated, but rather that their games are too simple.

The Path, for instance, is a surrealist reworking of "Little Red Riding Hood" in which the player takes the role of one of several girls walking through a forest to her grandmother's house. Each girl is told not to leave the path because of the wolf in the forest. That sounds straightforward enough.

But *The Path* punishes you for following its directions. If you stay on the path, you'll arrive at Grandma's, return home . . . and receive a message that you've failed. The player reaches a successful ending only by breaking the rules, taking each girl off the path, and letting her face her own "wolf." Moreover, the game defines success differently for every girl; you have to stray from the path as each character before the game will reveal its secrets.

The game plays with the fact that we tend to be comfortable following rules ("You're safe if you stay on the path"), but such compliance can hold us back from true understanding, both of ourselves and of the world around us. Thus, a simple game explores a challenging idea.

Steel wool to

clean the rust

A POWERFUL YET CHALLENGING MEDIUM

Although traditionalists might question the value of Tale of Tales' portfolio, both Samyn and Harvey believe firmly in the range of experiences and ideas that their style of interactive storytelling opens to artists and players. But one difficulty that artists face with game development is that building games is a mathematical process, dependent on seemingly sterile sets of rules. Some find it tough to bring their creative vision to life within those rules.

"It's horrible," Samyn laughed. "If you want to get really creative, you're up against a wall all the time thanks to the rigidity of the programming. Artists have very complex logic of their own; it's just that their minds work differently than a programmer's. I do think that's perhaps another reason there aren't as many interesting games from an artistic point of view."

And, for all the opportunities that game development offers, it also fundamentally changes the way artists approach their work.

In-game art from Bientôt L'été (Tale of Tales)

A book or film is interpreted by the audience, but ultimately the writer or director lays out the narrative and controls how the work is presented. In contrast, games offer an experience that is more like a conversation between players and artists.

"Sometimes, we feel like we do only half of the work," Samyn said. "The player not only has the imagination to complete the work, as they would with a movie or book, but they can actively change the narrative itself. We also like to make our games rich so players can express themselves and do different things depending on how they feel. That means we can't really finish a game like you would finish a book or a movie."

That connection between artist and player is central to Tale of Tales' creations, inspiring Harvey and Samyn to explore the capabilities and limitations of game development. In doing so, they have produced diverse and highly interesting games that fall outside the usual offerings and encourage us to explore our understanding of games and ourselves.

In-game art from Bientôt L'été (Tale of Tales)

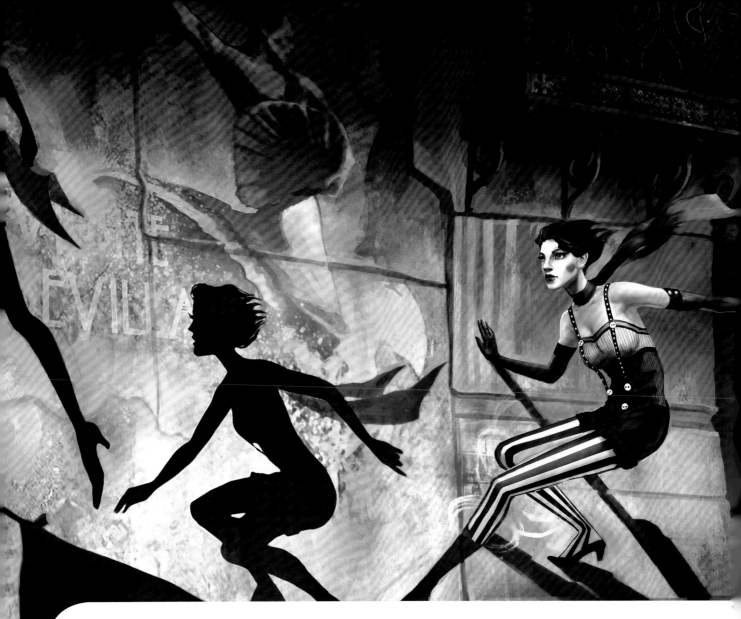

ESCAPE TO THE SHADOWS

When Compulsion Games created *Contrast*, founder Guillaume Provost's studio was just a team of eight. But thanks in part to a bit of luck, more than a million people have played the game.

As a means of promoting its new PS4 console, Sony offered selected games at no additional charge to

Concept art from Contrast (Whitney Clayton)

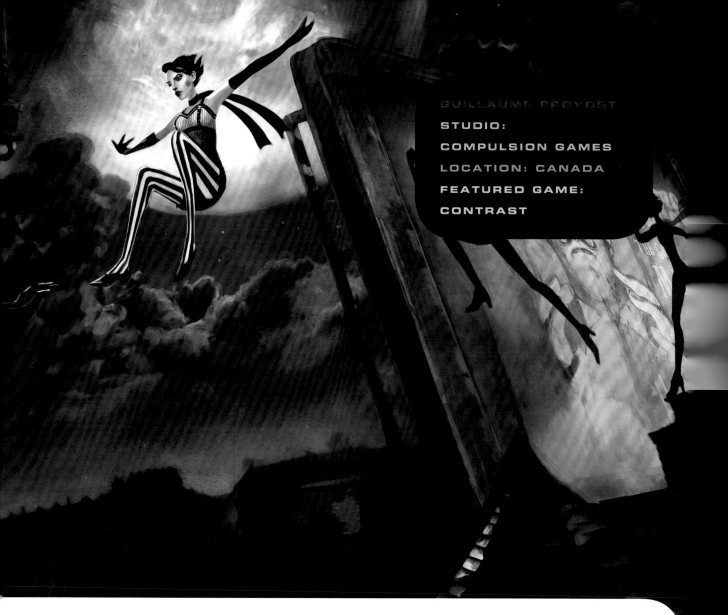

customers enrolled in the PlayStation Plus program. When *DRIVECLUB*, Sony's choice for the first game in the program, was delayed, Sony approached Compulsion, and *Contrast* was offered to a legion of new console owners.

"Not many projects of this type get that kind of exposure. It was great, as it let us share a different experience with a lot of people who might never have considered buying the game normally," Provost said. "We were able to reach players who might not have ever played anything but *Call of Duty* and other blockbusters."

Contrast would broaden the palette of PS4 gamers. Provost recalls showing off the game at PAX, the popular gaming conference, before

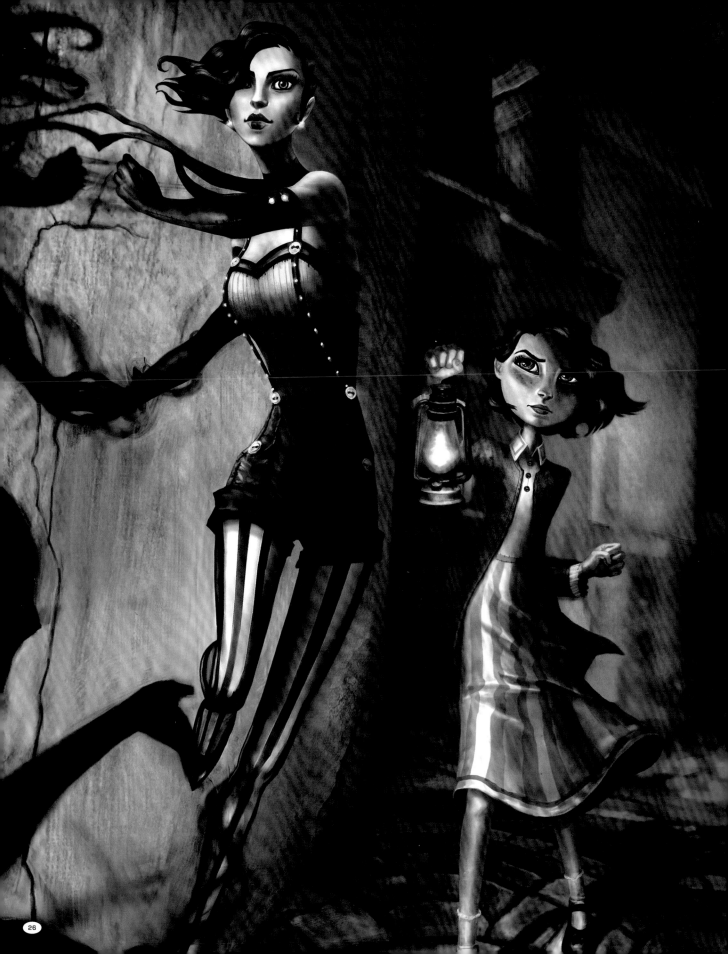

launch and reaching an often overlooked audience. "At one point, I looked around, and I think 90 percent of the people in front of our booth were women," he laughed. "There we were at PAX, and our game was one of the few that women were in love with. That wasn't something we anticipated. There's a good reason for it, though: women made up half of the team that worked on *Contrast*, so there's certainly a little more of a feminine touch to the game. That's especially true in terms of the visuals, thanks to our art director, Whitney Clayton."

A DIFFERENT PERSPECTIVE

The story of *Contrast* follows Didi, a young girl from a broken household, through a 1920s noir cityscape. Her father is a good-for-nothing; her mother is a cabaret singer; and her imaginary friend, a voiceless mime named Dawn, is all she has to help her cope.

Interestingly, you play as Dawn, not Didi. And just as other people can't see Dawn, Dawn can't see other people: from her perspective, the entire world is populated by Didi, shadows, and nothing more.

As Dawn, you have a limited ability to change the events unfurling around you; often, all you can do is watch. So you can manipulate shadows to help Didi escape danger, for example, but you can't prevent Didi's father from doing something stupid.

It's difficult to be certain of anything in Dawn's world, including whether Dawn herself even exists. You experience what Dawn sees and relays to you, but even that comes through a 10-year-old girl's point of view, making Dawn a highly unreliable narrator. This is meant to keep you guessing about what's really going on; although the unreliable narrator is a common literary device, it's still rare in games. But Provost wanted you to question what you see— and wonder what you're *not* seeing.

"We wanted to create mystery in the character," he said. "And I liked the idea that we were creating a world complex enough for players to fill in their own gaps by having them question what they're seeing going on around them. We've had some pretty interesting interpretations of the story!"

Opposite: Concept art from Contrast (Whitney Clayton)

Although Dawn's mysterious nature intrigues players, other characters can't interact with her, which meant Provost and his team couldn't make her—and by extension, the player—the focus of the story. Instead, they gave another character the lead role.

"The star of the narrative isn't so much the player as it is Didi," Provost said. "In a lot of the play sessions, it was actually difficult when players wanted background information on Dawn. But I kept bringing the team back to focus on what the kid was doing."

Along with Provost's desire to create mystery, several films inspired *Contrast*. The game's core mechanic is Dawn's ability to use the shadows of people, buildings, and so on as platforms to reach otherwise inaccessible areas. Shadows are so central to the game that the team modeled the story on film noir, which itself makes heavy use of shadows as a stylistic device.

"We were inspired by a number of films beyond noir," Provost said. "We love Tim Burton, and we looked to him for the shapes and the characters. From a contextual point of view, we found inspiration in Jean-Pierre Jeunet, who made *The City of Lost Children* and *Amélie*. We were also inspired by *Pan's Labyrinth* and the idea that the lead character of that film created a fantasy world to escape her reality."

But it's usually more comfortable to know, with certainty, that what's going on around your avatar is the game's reality, not an escape. The idea that you can't be sure whether anything you see and interact with is real creates a confusing, interpretive experience. You can't just sit back and follow along if you want to get the most out of *Contrast*.

WEATHERING THE STORM

Contrast was promoted through Sony's monthy subscription service. As it came from a new and unfamiliar brand, the free offer encouraged a lot of people to play something they probably would not have experienced otherwise. This was certainly a big plus as hundreds of thousands of players grabbed Provost's game, but it

Opposite: Concept art from Contrast (Whitney Clayton)

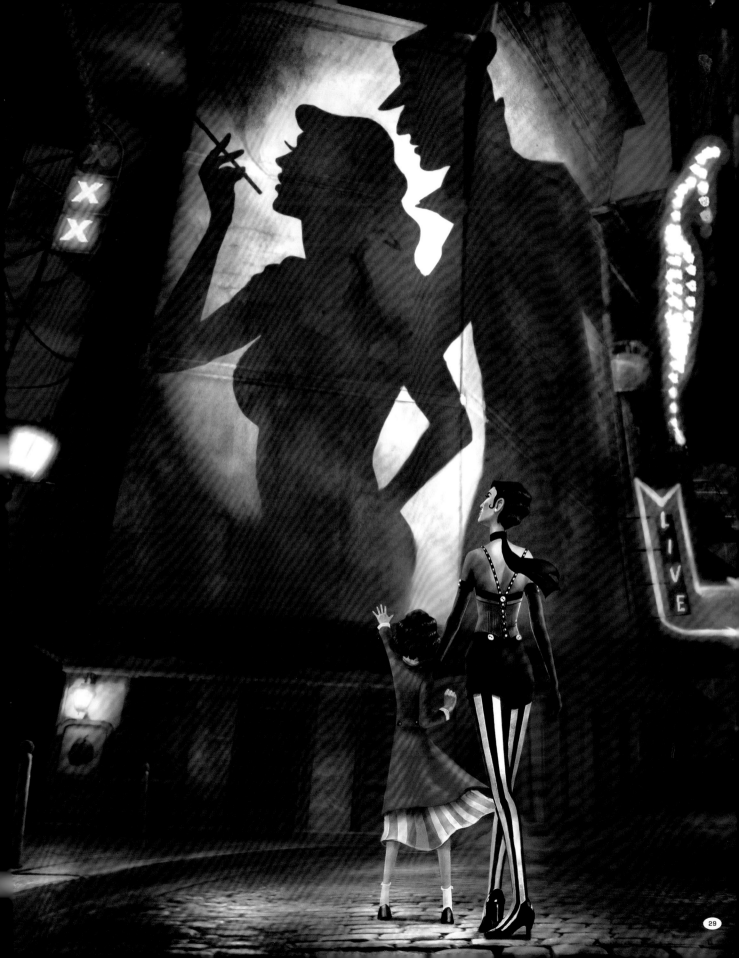

also meant that managing the expectations of players unfamiliar with this type of game became something of a hurdle.

"There was some confusion among the public and journalists as to the size and scope of the game. We had a lot to live up to, and I freaked out a little because we're an eight-man team. I don't know how many people worked on *DRIVECLUB*, but I surmise that it was more than eight!" Provost said.

Despite some critical initial reviews, Provost is confident that *Contrast* will be remembered as an art house hit: "Millions have played and appreciated the game, players that I never anticipated reaching when I set out. There was acknowledgment that our team had achieved something different from and more ambitious than a lot of the other games out there."

Concept art from Contrast (Whitney Clayton)

FOREVER INDIE

Provost has never worked for a developer with more than a few dozen people. Before founding Compulsion Games, he had worked on titles such as *Cel Damage*, but he's never wanted to work on a triple-A game.

"As a developer becomes larger, it starts to lose creative control over the intellectual property that it produces," Provost said. "That was especially true before digital distribution made it so we didn't need to sell through the expensive and competitive retail model. Many developers were stuck thinking, 'We're making a disc-based game, so we need to sell this many hundreds of thousands of units to break even.' For me, that was tiring.

"We were in this market where we had to dilute our ideas to try to appeal to everyone all the time. It became difficult to make creative and interesting games in the later 2000s. We just had to be the best at doing whatever the trend was at the time, which is by and

large the game that the big publishers are playing now. It's something I found increasingly difficult to cope with."

When Provost started work on *Contrast*, the games industry was very different, and indie developers still needed a publisher's support to get games manufactured and on store shelves. He rightly worried about getting a big company's attention in a time when the industry was very risk averse.

Provost laughed at the memory. "I remember walking into the offices of a major publisher and pitching this idea for a strange game about shadows, set in the 1920s, where you play the imaginary friend of a little girl. The response was, 'Whoa, you're *what*?' We started to reconsider our creative direction, as we had no idea if this game would ever see the light of day in its current form."

But the industry shifted. Platforms such as Steam, Xbox Live, the PlayStation Network, and Nintendo's eShop allow developers to sidestep traditional publishing models and self-publish their games. They might not outsell triple-A blockbusters, but small developers can sell enough copies to develop a fan base and sustainable business model.

In fact, these portals have almost single-handedly given the games industry the platform it needs to encourage offbeat, innovative thinking. Games like *Minecraft, Journey, Limbo,* and *Braid* have encouraged developers like Compulsion to stick to their creative vision—and the industry is better off for it. Sony might never have picked such an interesting, independent game to give away freely without these previous independent successes.

Provost counts himself lucky and sees a bright future. "All of this is a sign that the market is opening up. Indies are able to fill a space and satisfy a desire for creative games that don't follow the rules of the traditional entrenched structure," he said. "I think that has been a positive thing for the industry as a whole in terms of both commercial structure and artistry."

Opposite: Concept art from Contrast (Whitney Clayton)

THE
SUPERNATURAL
AND THE
SURREAL

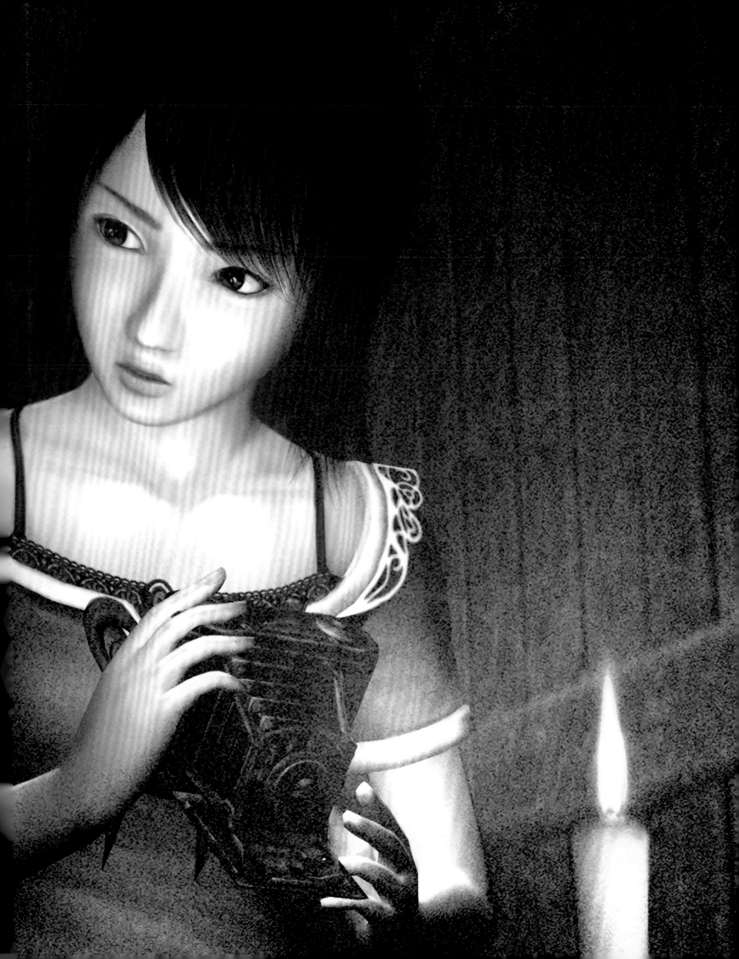

TURNING TRAGEDY INTO HORROR

Fatal Frame II: Crimson Butterfly (also known as *Project Zero 2*) is one of gaming's greatest horror masterpieces. It taps into primal fears and features plenty of horrific imagery, frightening ghosts, and jump scares, but it also tells a tragic story, a key element of Japanese horror.

Previous page: In-game art from Fatal Frame II (Koei Tecmo Games)
Above: In-game art from Deception IV (Koei Tecmo Games)

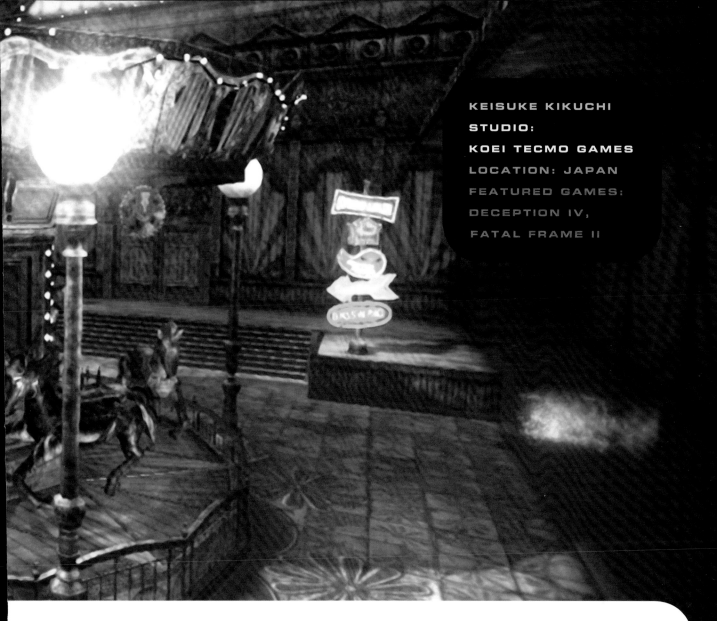

KEISUKE KIKUCHI
STUDIO:
KOEI TECMO GAMES
LOCATION: JAPAN
FEATURED GAMES:
DECEPTION IV,
FATAL FRAME II

Fatal Frame series producer Keisuke Kikuchi was fascinated by the concept of disrupted symmetry, so he put that theme at the center of *Fatal Frame II*'s narrative.

"It's actually where the subtitle comes from," Kikuchi said. "A butterfly's defining feature is that it has two wings that maintain a balance between left and right, and we started to think about how tragic and frightening it would be to have that equilibrium torn apart.

"So we created a story about twin girls who have to separate. As twins, they start life as one and forever feel drawn to each other. But they're pulled in conflicting directions, which is both sad and tragic. Loneliness and feeling incomplete are frightening experiences."

PLAYING MIND GAMES

Fatal Frame II tells the story of Mayu and Mio, twin girls who find themselves compelled to enter a haunted village. To prevent an evil force from escaping, the tortured spirits of the town require a devastating sacrifice. The elder sister has a decision to make: kill her sister or doom the world. The emotional weight of this choice gives *Fatal Frame II* a very different atmosphere from that of slasher films like *Halloween*.

Other differences in style are cultural. Kikuchi said, "Spirits and ghosts, they're not just monsters. In a lot of our stories and sayings, ghosts are people who left something uncompleted in life. The idea is that if you die with regrets, you reappear as a ghost. Japanese horror often focuses on the tragic rather than the monstrous."

Japanese horror tends to harness fear of the unknown as well: it delights in leaving you in the dark for much of the story, obscuring the ultimate narrative direction until the final reveal. Your imagination runs wild because you don't know what's going to happen to the main character or why. That void in your understanding is terrifying enough, but then the inevitable twist is often worse than anything you anticipated.

Fatal Frame II is designed to toy with your imagination, Kikuchi said. "The game's atmosphere relies on your perception of what could be filling that space. If you're in the dark, you squint to try to see more clearly. If you can't hear someone on the phone, you'll put it closer to your ear to try to hear better. When you're so focused on one particular thing, it's easy for something else to surprise you—or jolt you."

In *Fatal Frame II*, your character has a camera that lets you see into the spirit world. But at times, ignorance is bliss, and once you know what horrors lurk in the dark, you'll see them everywhere. "By using the camera," Kikuchi said, "you're able to focus on what's in the dark, which means you start to imagine what's in every corner. You see things that aren't there for most people, things that shouldn't be seen."

Opposite: Promotional art for Fatal Frame II (Koei Tecmo Games)

FACING YOUR FEARS

While some of *Fatal Frame II*'s cutscenes are disturbing, gameplay has you taking photos of creatures rather than physically battling them. As Kikuchi put it, "Guns and swords don't work to kill ghosts."

He laughed, adding, "I've always wondered why other horror games try to make physical confrontation the scary part. In those games, whenever your character gets defeated or is killed, it's game over! If it's a horror game, it's meant to be scary. Why would there be a penalty for coming into close contact with the scary thing?"

Ghosts in *Fatal Frame II* can kill the player, but instead of discouraging you from approaching spirits, Kikuchi and his team implemented a clever mechanic: the closer you are to a ghost when you take a photo of it, the more damage you'll do.

"You have to use the camera to see the ghosts, but they're not something you want to see," Kikuchi said. "Then you have to let them get close to you when your instincts are telling you to keep them far away."

PLAYING EVIL

Kikuchi's dark repertoire isn't limited to the *Fatal Frame* series; he's also worked on the well-known *Deception* franchise. *Deception* plays a different mind game: it inverts the traditional video game narrative structure, putting you in control of an evil being. You must protect the land from invading forces of righteousness, and the range of gory traps at your disposal includes a banana peel, an iron maiden, swinging blades, and even *Indiana Jones*–style giant rolling boulders.

"When I was starting out, I didn't anticipate being best known for my work on dark games!" Kikuchi said. "But I've always wanted to do things differently and give people a new experience."

He described the context in which he started designing the first *Deception* game. "There were so many adventure games and RPGs that cast players as heroes on a quest to defeat evil that I thought, 'What if we do the reverse?' It's common to do that now, but back then, it was new. It's difficult to make a game where you're the

evil one without it being in the context of a dark game, so I guess that's where my reputation comes from."

But according to Kikuchi, it wasn't easy designing a game in which the player takes on the role of an evil villain.

"Your enemies are stronger than you," he noted, "but we also make sure that it's not exclusively a tale of good versus evil. For every father trying to defeat you to earn bounty money to buy medicine for his daughter, there is a pretentious, self-righteous hero or an equally dastardly villain to take down. This way, you get to enjoy the story while still being in control of an evil character, and you don't feel like you're part of a glorification of evil."

The *Deception* games also have a sharp sense of humor, which lightens their dark theme a little. Kikuchi said that this comedy was inspired by the slapstick game shows that have been popular in Japan over the years.

"Digging a hole and covering it so people fall in, or taking a bucket of paint and balancing it on the top of a doorway so the next person who comes into the room gets covered in paint—these things are a little sadistic, but they can also be very funny."

A LIFELONG PURSUIT OF ART

Unlike many other game developers, Kikuchi wasn't able to play games as a youngster. His parents were teachers, and they thought he could do better things with his time than play video games. But he loved games so much that he found a clever loophole.

"I would watch my friends play games and say to myself, 'So, that's how the dots move,'" Kikuchi said. "Then I would go home and draw these characters myself, cut them out, and make my own twist on video games with the paper cutouts."

Opposite: Box art for Deception IV (Koei Tecmo Games)

"I always wanted to do something creative, and when I was at university, I got involved in producing eight-millimeter films. I wrote the scripts, recruited the actors, filmed and edited them. I loved being able to create something and then see the audience respond to it.

"When it came time to find a job, I wanted to do something in film or television. But with a major in mathematics, the only creative field that really fit with my experience was game design, and I only applied for one job. It was a job at Tecmo, and I remember 21 years ago going into a job seminar and being told that because the games industry was so young, I would get the opportunity to create and direct my own game while I was still young."

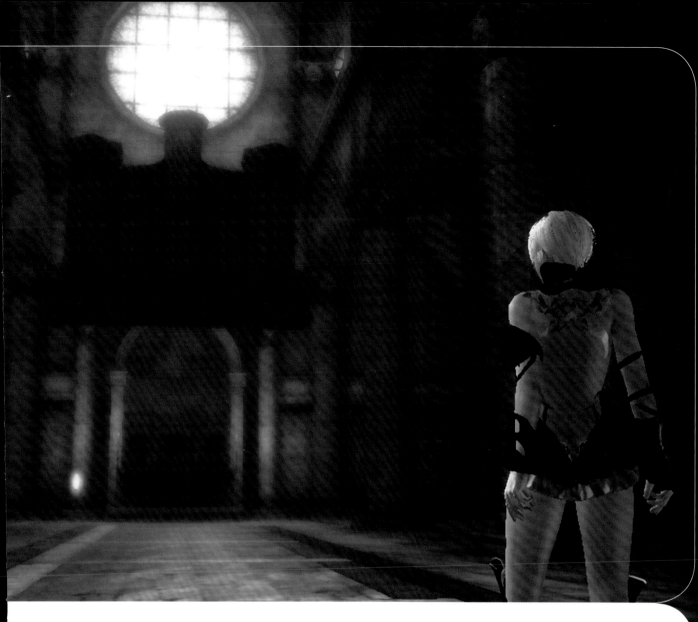

Kikuchi is still interested in other art forms, and he dabbles in them whenever possible. But one of the things that has kept him in the games industry for so long is just how perfectly it incorporates all the elements of artistic creativity.

"When making games, you get to be involved in cinematics, music, and visual art, and—of course—interactivity," Kikuchi said. "It really does feel to me that games cover so many different art forms."

Young Girl

She knows

☑ Playing happily

PUSH / GRAB

☑ Mole near her ey

No, it couldn'

PLAYING DETECTIVE

Hidetaka Suehiro, popularly known as SWERY, is the writer and director of crime-thriller *D4: Dark Dreams Don't Die*, in which the protagonist, detective David Young, uses mementos to travel back in time and investigate his wife's murder. Creating the mechanics for a game like this is a balancing act. Give players too much freedom, and they may get confused and frustrated. On the other hand, restrict

In-game art from D4 (Access Games)

HIDETAKA SUEHIRO

STUDIO:
ACCESS GAMES

LOCATION: JAPAN

FEATURED GAME:
D4: DARK DREAMS
DON'T DIE

players too much or make the clues too easy to follow, and they won't feel like they're doing much detective work.

To tackle this challenge, Suehiro took inspiration from novelistic traditions. "It's basically like a visual novel," he said. "There are free sections, but we didn't want players searching for important bits of information.

We also wanted to preserve the flow of the game, so we started to think about how we could get players into the mind of a detective in another way."

D4 is completely linear, and as with reading a mystery novel, your ability to stray from the preset story is limited. This narrative structure allowed Suehiro to guarantee players could

see the game through to completion without getting stuck, while players are also rewarded for "getting inside" detective Young's mind. Successfully completing puzzles and answering dialogue options as Young would, based on his characterization, earn you points toward a high score, but picking the wrong dialogue option or failing in a puzzle doesn't end the game.

EMPATHETIC CHARACTERS

In many games, characters are little more than tools you manipulate to progress through the world, but Suehiro focuses on getting players to engage and connect with his characters. Just as readers connect with the characters of classic novels, he believes that games can have great characters and don't have to rely purely on the player's agency. He wants you to think *like* the character and think *about* the character, and the stories in his games center around what happens to the character.

Suehiro's desire to create characters that players want to engage with comes from his firm belief that it's time for games to be taken more seriously as artistic pursuits. "I get the question about how I see games as art all the time these days," he said. "I do wish that people would take games more seriously as art, and this means taking the themes and characters more seriously, not just the visual style and action. But then if people don't buy the games, no one can get the message. So we need to balance the artistic value of the games and the entertainment they provide."

TIMELESS ART

Suehiro is one of the few game directors with an entry in the *Guinness Book of World Records*. His horror game, *Deadly Premonition*, has been called the most polarizing game ever released: some critics praised its unique style and its cinematic depth reminiscent of David Lynch, but others weren't able to get over its gameplay or its graphical and technical faults. Suehiro takes the somewhat dubious honor in stride.

"When I was younger, perhaps I would have been more upset by the reviews," Suehiro laughed. "Lots of people did

understand me and what I was doing with the game, and others didn't, but that's okay too. Ultimately, the game's producer encouraged me to make a game according to my own vision, and not everyone is going to agree with my ideas.

"I never think that the critics of the game are wrong, either. The consumer pays for the game, and if that consumer paid expecting quality graphics, then of course they were going to be disappointed by *Deadly Premonition*. Every consumer wants different things from games, and it's difficult to make something for everyone."

With this in mind, Suehiro worked hard with the art director on *D4* to ensure the game would receive a positive response from the critics and community. They knew that the

In-game art from D4 (Access Games)

☑ Clover Print Paper

Still smells like her

game needed to be more beautiful and accessible than *Deadly Premonition*, and since *D4* is an episodic series with no set end point, they also wanted an aesthetic that wouldn't have to change, no matter how long the series continued and how far technology progressed.

The result is a stylish, cel-shaded look, much like that of a graphic novel, and the strategy seems to have worked. The first episode

of *D4* is popular with both critics and the community, a response that has certainly pleased Suehiro.

"We wanted revenge for the response that *Deadly Premonition* got from some corners," he laughed. "We really wanted to make something that people could appreciate visually."

Following page: In-game art from D4 (Access Games)

FANTASY WORLDS

INDIE FREEDOM IN A TRIPLE·A STUDIO

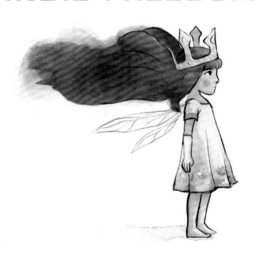

The centuries have been unkind to us,
Gods forgotten within white temples fade.
Under lidded eyes the palace sits, frayed,
Doors closed, behind bleached rooms gathering dust,
The gilded throne's gleam muted by dull rust.

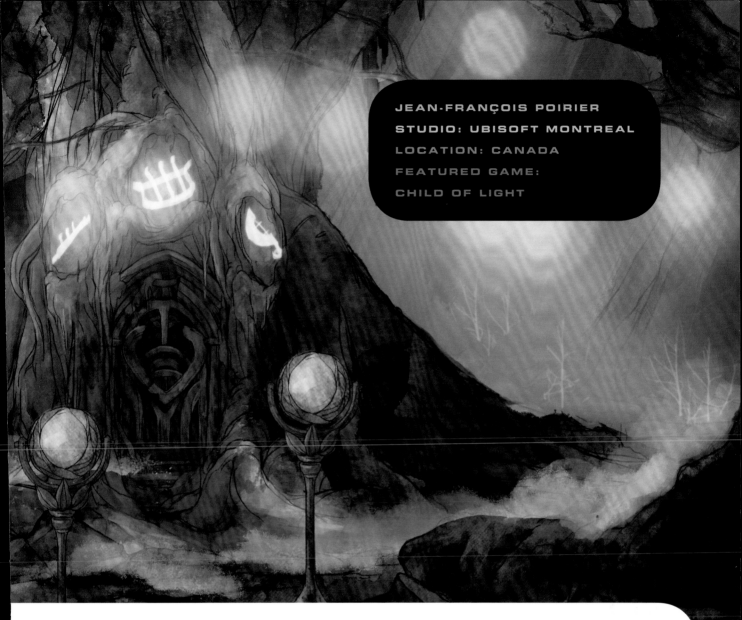

JEAN-FRANÇOIS POIRIER
STUDIO: UBISOFT MONTREAL
LOCATION: CANADA
FEATURED GAME:
CHILD OF LIGHT

Child of Light is an interactive poem. Every line of dialogue, every cutscene, and the very pacing of this gorgeous game follow a steady, rhythmic beat. The playing experience shines with as much heart and soul as any indie game, but *Child of Light* was in fact created in-house at Ubisoft, a multinational corporation and now the third-largest games studio in the world. Ubisoft offered producer Jean-François Poirier and a small team of the company's

Previous page: Concept art from Child of Light (Ubisoft Montreal)
Above: Concept art from Child of Light (Ubisoft Montreal)

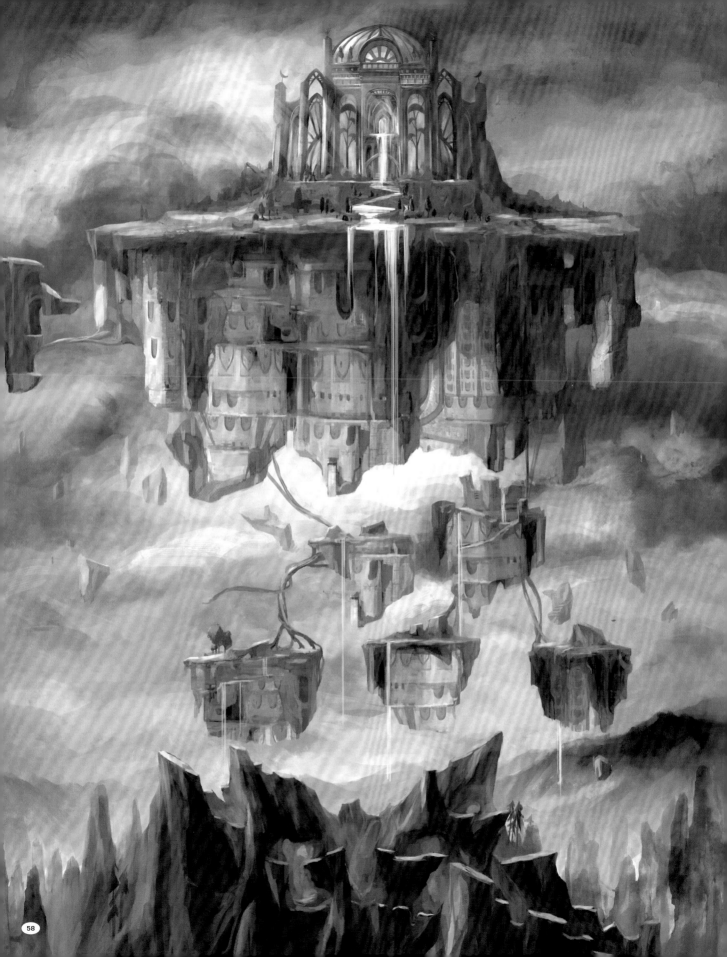

most experienced developers a unique opportunity to achieve something purely creative, but with access to resources that independent developers can only dream of.

"The project attracted a lot of senior staff," Poirier said. "We are fortunate that at Ubisoft Montreal, we get to work on a lot of big projects, but some of the veterans have been working on blockbuster games for the past seven or eight years. A game can take four years to make, and we've been working on these cycles for long enough that the opportunity to do something different was very exciting!"

BRINGING PLAYERS TOGETHER

Poirier and his team were free to make decisions around character and environment design that spoke to their own aesthetics and experiences. For example, many members of the *Child of Light* team had been inspired to become developers by the classic *Final Fantasy* series, and their nostalgia for that series informed the combat system. *Final Fantasy* also inspired the art direction, as the developers were heavily influenced by the work of legendary Japanese artist Yoshitaka Amano. And from the start, their love of playing games with family and friends ensured a commitment to making *Child of Light* a game that players could enjoy together.

"We wanted this to be an experience that players could share with loved ones. That's why we deliberately left the cooperative gameplay offline. I've had people come to me and say *Child of Light* was the first game they played together as a couple. Hearing that made me feel like this game was a big success," Poirier said.

"I even made a dress based on the game to give to my daughter because during development, she watched the evolution of the main character, Aurora, and loved the design of the dress," he continued. "She is a bit young to play the game by herself, but she was able to help me on my quest by controlling Igniculus, a minor character built for a second player to control."

PLAYABLE POETRY

Poirier always wanted *Child of Light* to be an accessible RPG—a game that everyone, regardless of experience, would be able to complete. Readers can't fully understand a poem without reading all the way through to the end, and the same goes for *Child of Light*. At just 12 to 15 hours of gameplay, it's a lot lighter than most role-playing games today.

"It's not as deep as other RPGs, but that's because we want all players to finish the game and enjoy the quest, and we want them to share the experience with their families." Poirier said. "RPG elements were part of the DNA of the game from the start, but at the same time, we wanted the feel of a playable poem. At one point when we balanced the game, we cut out half of the fights because

Above and opposite: In-game art from Child of Light (Ubisoft Montreal)

we felt it was too heavy and repetitive. We were trying to find the right balance so that the player could explore and enjoy the ride and visuals."

A FRESH TAKE ON FAIRY TALES

Poirier and his team had a distinctive vision for *Child of Light*. For one thing, they took this opportunity to elaborate on the standard RPG tropes, bringing some mature themes into the game.

"The symbolism and simplicity of fairy tales were very appealing to us all, but we also wanted to do a modern story," Poirier said. "We didn't want a princess waiting for a Prince Charming. We wanted the opposite—

we wanted to tell the story of this girl who needs to face challenges in life and use her gift to help others, a story of growing up. And we were looking to have players develop an emotional connection with the characters on the journey."

Child of Light is a coming-of-age story, a theme that's been around as long as people have been telling stories. It speaks to a universal human experience: the transition from childhood to adult responsibilities and understanding. Through the narrator's growth, we learn about ourselves, the world around us, and our role in it. *Child of Light* might be best called a bildungsroman, a story that focuses on how an individual grows psychologically and morally.

Princess Aurora's quest transforms her from a spoiled girl into a woman who values friendship, teamwork, and compassion. But how much support she has along the way depends entirely on the player's choices, and this was a deliberate design decision by Poirier and his team.

"We were careful to tie the story and moral themes into the gameplay," Poirier said. "For instance, you can meet partners in the game—but you have the option to avoid side quests that would give you allies in combat. You can choose to face Aurora's challenges alone, but in life, it's easier to address challenges with a team, so you're encouraged to have Aurora help other characters with their challenges even as she journeys on her own quest. And then they in turn will help her out."

As in most RPGs, your character in *Child of Light* starts alone and weak, but as you progress, you become stronger. You learn about the game world and recruit more heroes to your cause. In this way, the game's traditional RPG structure parallels its story of personal growth.

ALWAYS LOOKING AHEAD

After all the work that Poirier and his team put into the rich, vibrant world of *Child of Light*, Poirier certainly hopes to see more adventures happen in this universe. These developers aren't relying on chance, though.

They kept the possibility of a sequel in mind throughout the game's development, even though they wanted the game to be self-contained.

"We wanted *Child of Light* to have closure," he said. "We didn't want to leave people hanging. But on the other hand, from the beginning, we wanted to build a universe that could sustain several other opuses. We wanted to set up the foundations to evolve in this world. There's stuff in that game that very few people would notice, and we can build that up or spin it out as we like.

"And *Child of Light* was a coming-of-age story—but now Aurora is an adult. There are plenty of stories we could tell in which she returns to this world. Creatively speaking, there's a lot we can do yet!"

Concept art from Child of Light (Ubisoft Montreal)

RISING FROM THE ASHES

Building your own game universe is a huge creative undertaking, but what if you had to put together the pieces from someone else's failure? Naoki Yoshida, a 20-year veteran of the Japanese game development scene and the director and producer of *Final Fantasy XIV: A Realm Reborn*, has firsthand experience with just such an effort.

Concept art from Final Fantasy XIV (Kiyoshi Arai/Square Enix)

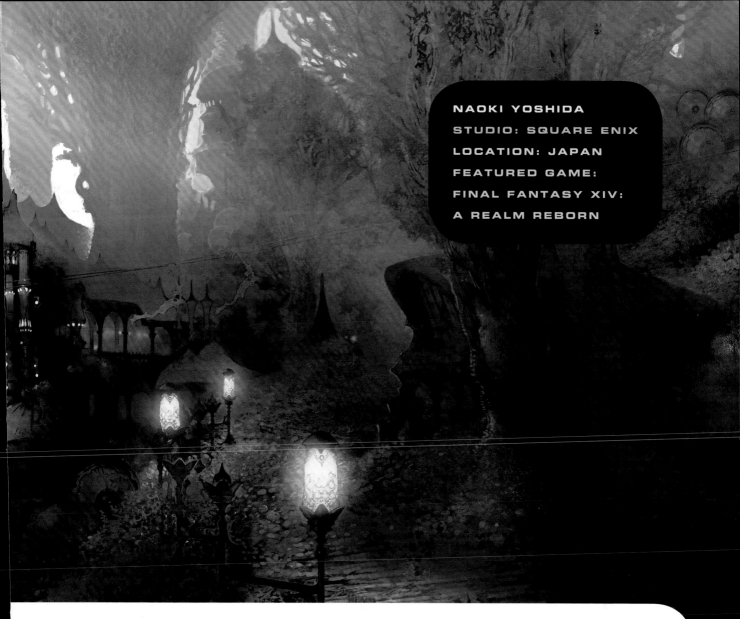

NAOKI YOSHIDA

STUDIO: SQUARE ENIX

LOCATION: JAPAN

FEATURED GAME:

FINAL FANTASY XIV:

A REALM REBORN

A Realm Reborn is his complete reworking of Square Enix's second *Final Fantasy* MMO, *Final Fantasy XIV,* which was released in 2010. The original release didn't resonate with players, and critics panned it. The player base dropped rapidly mere months after release, but for Square Enix, letting one of the oldest, most esteemed Japanese role-playing franchises die quietly just wasn't an option.

That's when Yoshida stepped up to breathe new life into *Final Fantasy XIV.*

ENDING THE WORLD TO SAVE IT

When asked how other developers might learn from his work on *A Realm Reborn*, Yoshida actually laughed. "I hope no one else has to do what I needed to do. It created so many challenges, and not so many

opportunities, when compared to building a game from scratch. If you're going to make something with your name attached to it and take personal responsibility for it, starting from scratch is far preferable. It's a more personal work then."

But as challenging as the project was, rebuilding a game ultimately allowed Yoshida to bring his own vision to life. Rather than try to fix *Final Fantasy XIV*'s problems one at a time, Yoshida had a dramatic plan: he would write a narrative that would literally destroy the original game's setting. After that in-game apocalypse, a new and improved experience could emerge from the ashes like a phoenix.

PRESERVING THE BEST PARTS

Two million registered players later, it's clear that Yoshida's strategy worked. *Final Fantasy XIV: A Realm Reborn* stayed true to the original and effectively reset the in-game universe, without breaking continuity for players who had experienced the first world. Yoshida didn't choose to throw all of the material from *Final Fantasy XIV* out the window—there were parts that he believed in, and he made sure they stayed.

"If I were making this game entirely from scratch, I might not have thought of the armory system, for example, where players can swap their equipment and immediately adopt a new role," Yoshida said.

In *Final Fantasy XIV,* equipping your character with a bow makes you an archer, and then when you fight enemies, the experience you gain counts toward new archery skills. Swap to a sword and shield, though, and you'll earn warrior skills instead. Yoshida was keen to maintain this feature, which is unique to *Final Fantasy XIV*, because he felt that's how today's MMO players would want to play.

"With most MMOs, if you wanted players to try different jobs, you would ask them to set up a second character," he said. "I think a game that allows players to swap between classes whenever they like is

more relevant to the modern gamer. It does a better job of taking into account their motivation and the life cycle of the product."

BALANCING NARRATIVE AND AGENCY

Since it debuted on the Nintendo Famicom in 1987, *Final Fantasy* has pushed boundaries its contemporaries tend to shy away from. For one thing, it focuses on epic storytelling and characterization. In addition, traditional *Final Fantasy* games often pose philosophical quandaries, and as the characters wrestle with them, you have an opportunity to reflect on complicated questions of right and wrong while not actually making those choices yourself.

For example, complex, nihilistic villains like *Final Fantasy VI*'s Kefka force you to ponder your own sense of morality. Kefka's actions are reprehensible, but perhaps from a certain vantage point, there is a higher purpose that contextualizes, if not justifies, his choices. *Final Fantasy XIII*'s concluding chapter, *Lightning Returns*, asks you to consider Lightning's actions as she battles destiny in three different games. It questions the consequences of rebellion, the nature of heroism, the value of family, and whether the game's villains are truly villains.

Even though you can't influence those stories, they're still powerful experiences, and naturally, many *Final Fantasy* veterans approached *A Realm Reborn* expecting something similar. But *A Realm Reborn* is an MMO, and MMOs usually ask you to write *your own* story through a character you create and the actions you take.

In an MMO, the story is also defined by the social aspect of the game. You'll form alliances and go on quests with other players from around the world. You might rise to glory in competitive battles with other players or amass a fortune to buy virtual real estate. The key here is that your experience in an MMO is fundamentally different from the experience of any other player.

Both forms of storytelling are complex, and they're not necessarily compatible. If you

Opposite and following page: Promotional art for Final Fantasy XIV (Square Enix)

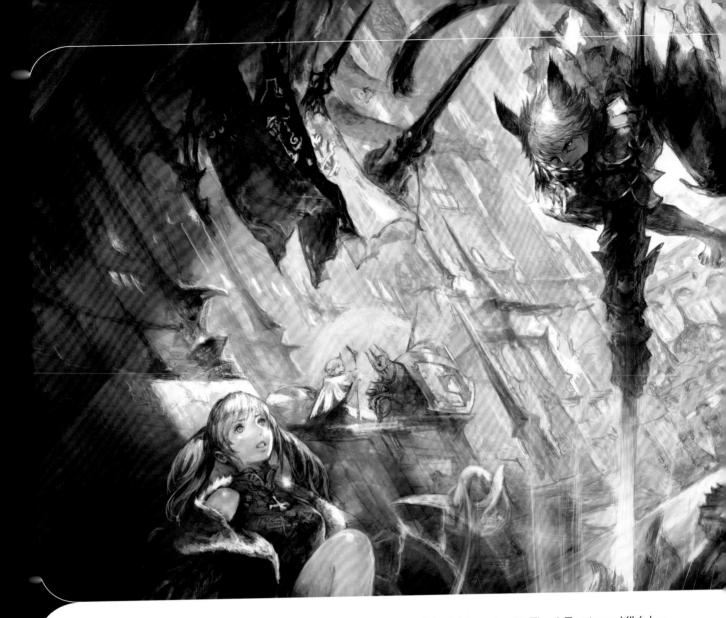

could side with Kefka in *Final Fantasy VI* or have Lightning and her allies resign themselves to fate instead of fighting back in *Final Fantasy XIII*, you wouldn't have much of a game left to play. And in an MMO, if you're forced to follow a preset path, you won't feel connected to the world or form the relationships with other players that give these games their dynamism.

When Yoshida rebuilt *Final Fantasy XIV*, he faced a clash between those concepts: how could *A Realm Reborn* keep the series' signature narrative traits yet teach MMO mechanics to *Final Fantasy* fans who were new to the genre?

Yoshida's answer to this challenge was seemingly simple: why not blend the best

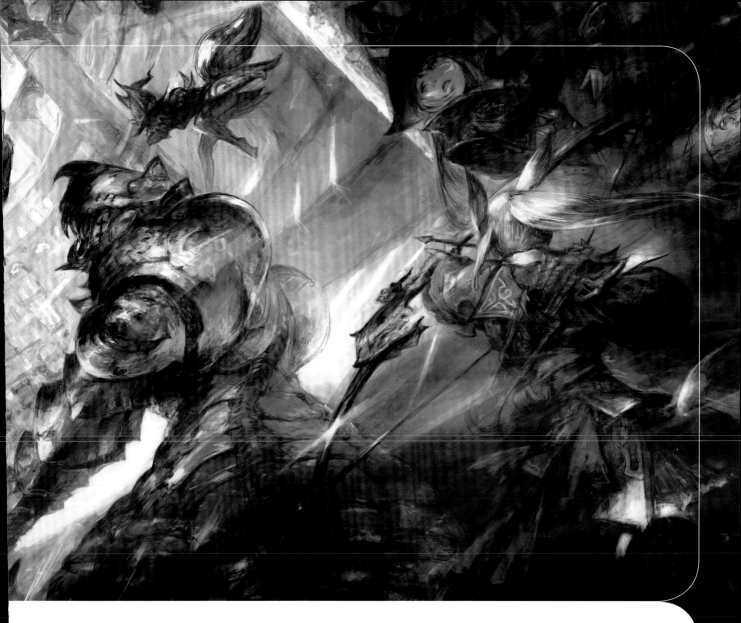

of both genres? For the first dozen or so hours of *A Realm Reborn*, players experience a traditional *Final Fantasy* epic, with no real need to interact with others outside the occasional dungeon. Even then, the game randomly assigns a couple of allies to players so they don't need go out of their way to create teams. Yoshida's hope is that once you finish that first story arc, you'll be comfortable with the controls and ready to dive into the full MMO experience of social interaction, enemies so challenging that multiple players are required to take them down, and player-versus-player combat.

Above: Concept art from Final Fantasy XIV (Kazuya Takahashi/Square Enix)
Following page: Cutscene from Final Fantasy XIV (Square Enix)

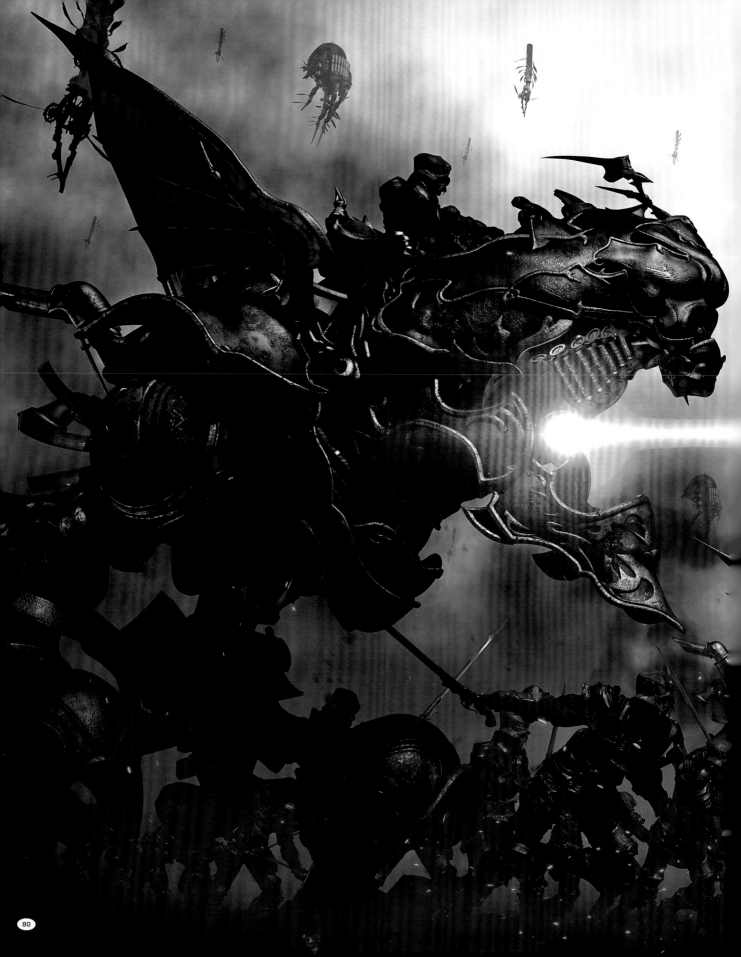

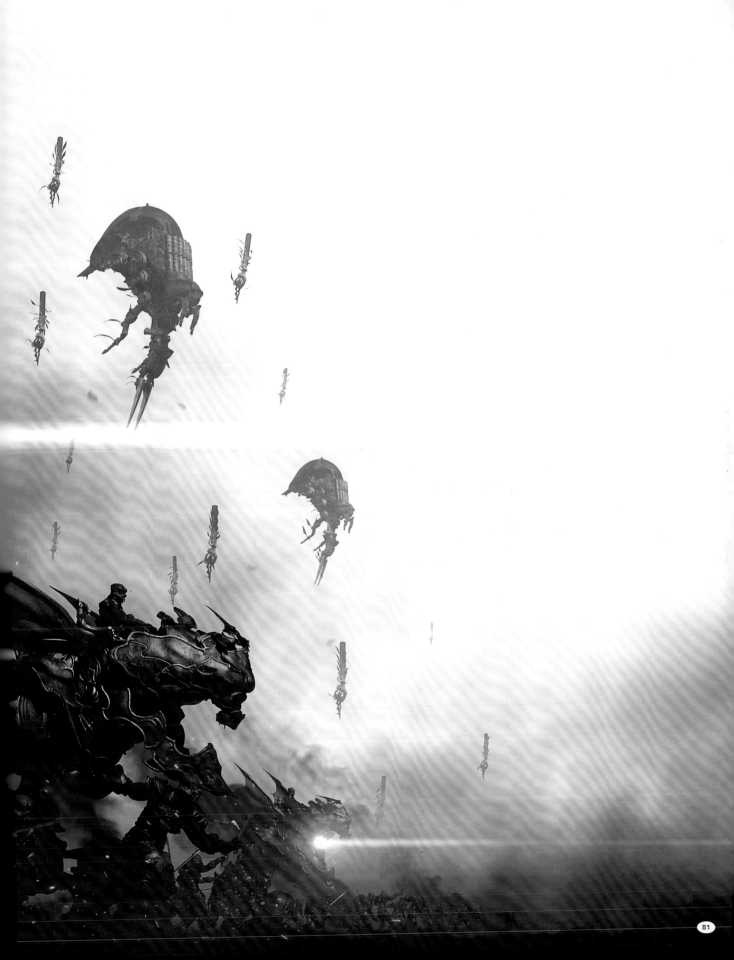

"I thought that a story would be really important," he said. "If the MMO genre has one weakness, it's the fact that if you're not a serious gamer, you may find it difficult to appreciate the abstract design and mechanics, and there is no one to guide you through. But if there's a good story, players will want to know what's going to happen next, and by simply experiencing that story, they're going to gradually learn how to play the game."

A BLANK SLATE

Yoshida was also careful to use the story and dialogue of *A Realm Reborn* to heighten the player's sense of agency. For example, he made the protagonist—you—silent so you can imbue your character with your own personality. Nintendo's Shigeru Miyamoto pioneered this trick in his *Legend of Zelda* series, in which the lead character, Link, has always been mostly mute, making him a blank canvas for players.

Yoshida wanted the same effect, so in *A Realm Reborn*, other characters have voices during cutscenes, but your character never talks. Hearing your character speak would violate your immersion in the world, removing the agency that an MMO demands. Instead, you can give your character whatever personality you like and express that personality though actions such as cheering, dancing, and even a "dislike" gesture.

Yoshida and his team offered players agency by writing dialogue that directly addresses you and by never forcing you to advance the plot until you're ready.

"We wanted to make sure the player is the main character in the game, which is why we paid attention to every single dialogue sequence," Yoshida said. "Characters in the game will say, 'We need your help. We need you to do this for us.' We needed to make sure the player was always personally asked to save the world. We did not make a rail path for players to follow; everything they do within the world is their own decision."

Opposite: Cutscene from Final Fantasy XIV (Square Enix)
Following page: Concept art from Final Fantasy XIV (Kazuya Takahashi/Square Enix)

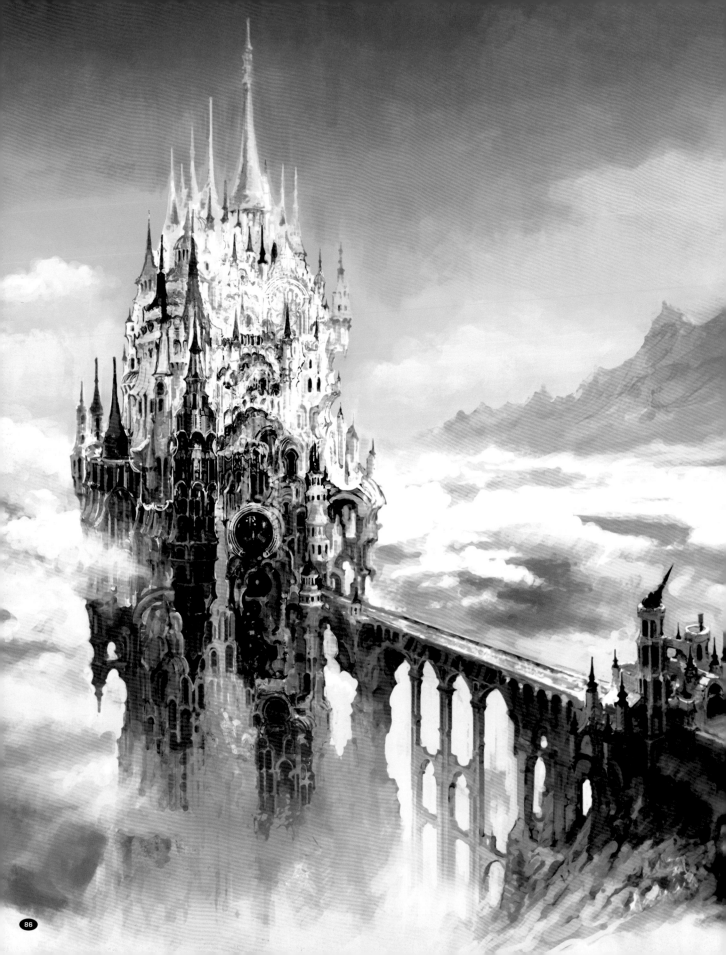

DESIGNING FOR FUN

Yoshida loves literature, especially classic detective stories, and he always knew he'd write something himself. "From a young age, I felt that I wanted to write text for games," he said. "It was always about the games; I never thought of going in any other direction!"

All it took was one fateful encounter on the Famicom to set Yoshida on that path to a career in game development.

"The winter that *Mario Bros.* was released in Japan, a friend invited me over, saying big things about how great this experience was. So I visited his house and played *Mario Bros.* for the first time," Yoshida recalled. "It was really shocking that I could hold the controller in my hands and make the character do things on the screen!"

Yoshida liked how each person who played the game could get something different out of it. "Even though it's in the same world, if you're playing solo or playing with a friend, you can have a totally different experience. For example, when you're playing with two people, you can choose to cooperate with each other—or you can get in each other's way and start competing."

Those varied experiences provided players with hours of fun. Even today, Yoshida prefers to think of his creations as pieces of entertainment that offer players an endlessly fascinating freedom within the game space—just like the freedom he experienced as a child with *Mario Bros.* on the Famicom. *Final Fantasy XIV: A Realm Reborn* and the other games that he has worked on, like *Dragon Quest X,* are undeniably artful, but Yoshida has never actually considered himself an artist.

"Perhaps in 100 years people will decide my work is art, but I've never thought of it that way," he said. "Ten years ago, when the computer game was introduced to mass culture, it was treated as a curiosity, as something new. Now, a generation of people is growing up and games have always been a part of their lives, so games are more like film."

Opposite: Loading screen from Final Fantasy XIV (Square Enix)

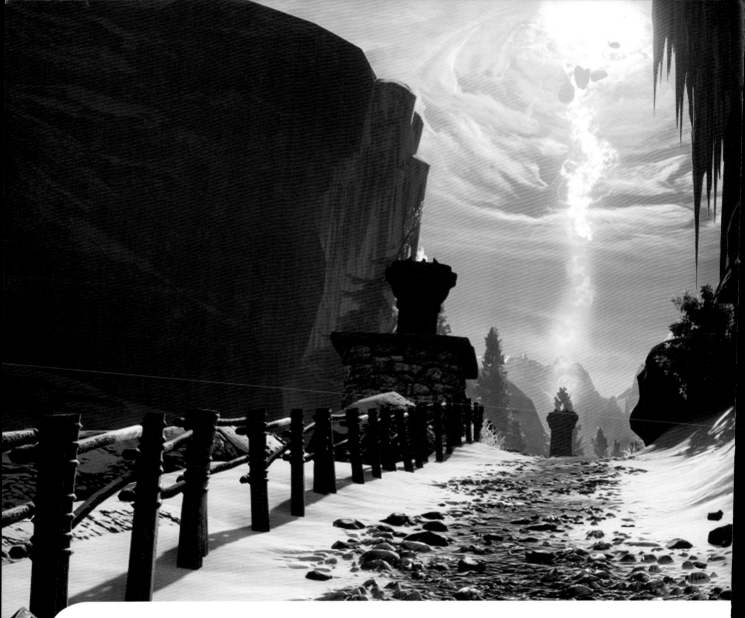

UNCHARTED TERRITORY

Known for exploring narrative potential and player agency in its games, BioWare is the company behind classics like *Baldur's Gate*, *Jade Empire*, *Star Wars*: *Knights of the Old Republic*, *Mass Effect*, and *Dragon Age*. Its focus on player agency has allowed the company to explore moral and ethical themes in some depth. Indeed, the core narrative of the *Dragon Age*

In-game art from Dragon Age: Inquisition (BioWare)

MIKE LAIDLAW
STUDIO: BIOWARE
COUNTRY: CANADA
FEATURED GAME:
DRAGON AGE: INQUISITION

series gives players a multitude of tools (both righteous and otherwise) to oppose their enemies.

Mike Laidlaw, the creative director of the *Dragon Age* franchise and a writer on the original *Mass Effect*, has been fascinated with the potential of video games to tell stories and empower players since he was a child.

"I grew up on a farm, but when I was six or seven, my parents bought a Commodore 64," he said. "After a couple of weeks, my dad saw me building levels in *Lode Runner* with no memory on the cartridge to save them, so he also bought a disk drive. Having parents who supported my video game habit was a pretty formative experience for me. You

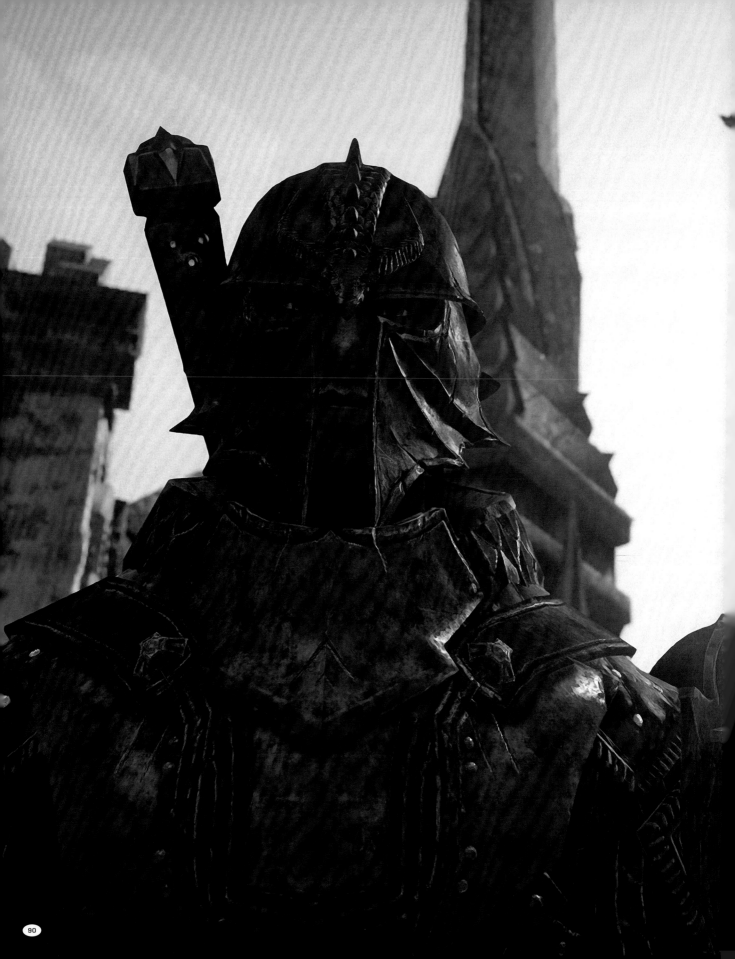

wouldn't think of traditional dairy farmers doing that, and yet here we are!"

Laidlaw cut his teeth playing games like *Star Control II*, *Wasteland*, and *Neuromancer*, yet he didn't enter game development immediately after leaving the farm. Instead, he worked in a job he hated for a while. Then he saw an advertisement for a writing position at BioWare. He applied immediately, and he's been with the company ever since, calling his experience there his dream career.

"The uncharted territory of agency has always drawn me toward game development and storytelling," Laidlaw said. "I love that dynamic tension between wanting, as a developer, to enable players to do everything and needing to provide a structure and say, 'Here's the range of things you can do in this game.'"

BioWare has enabled Laidlaw to explore this tension, and the *Dragon Age* franchise has brought that exploration to fruition.

VILLAINS AS HEROES

Dragon Age is a dark fantasy epic in the vein of J.R.R. Tolkien's *The Lord of the Rings* or George R.R. Martin's *Game of Thrones*. Demons and orc-like monsters called the Darkspawn threaten humanity, but humans face equal threats from within, as corruption and pride lead some of the powerful astray. How you relate to that world greatly influences your actions as a player. You'll be forced to make difficult decisions, right down to who lives and who dies, as you navigate the dangers of both monster-filled dungeons and human politics.

"The core theme of the *Dragon Age* franchise is that people are fundamentally flawed, and that's okay," Laidlaw said. "We explore villainy and heroism as a structure of compromise. Villains are always the heroes of their own story as opposed to an actual evil—they are all trying to do the right thing in the face of the overarching threat of the Darkspawn.

Opposite: In-game art from Dragon Age: Inquisition (BioWare)
Following page: Promotional art for Dragon Age: Inquisition (BioWare)

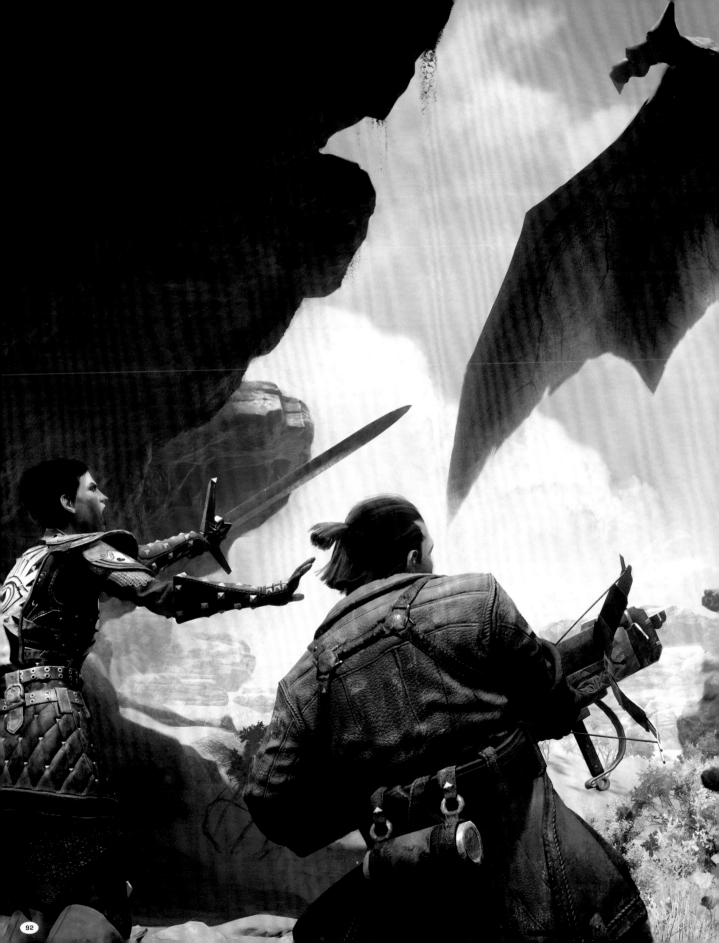

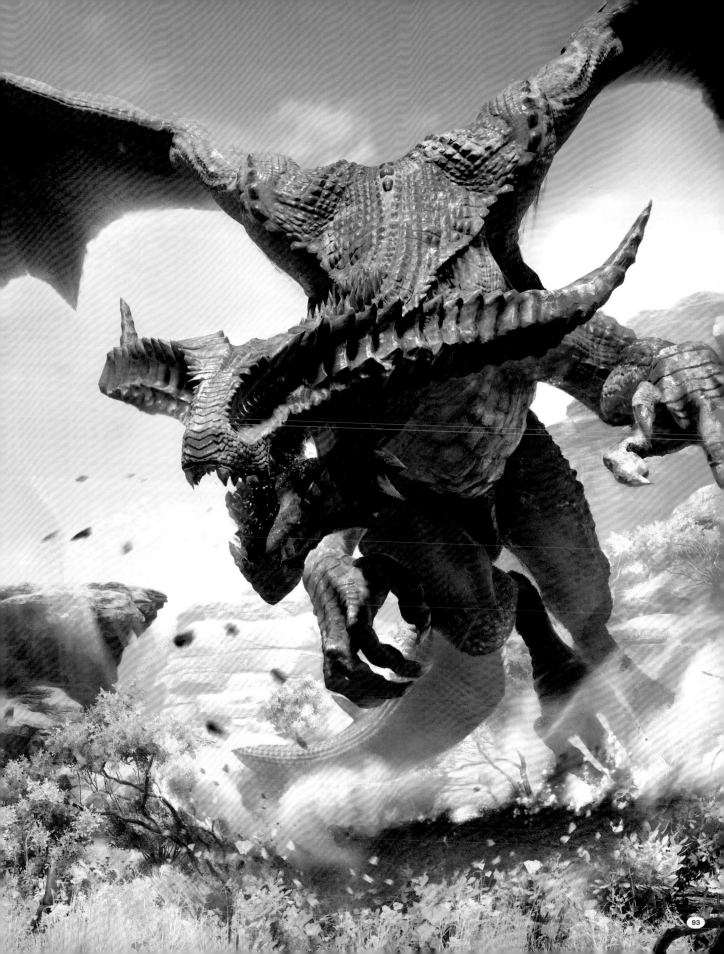

"For example, one of my favorite scenes in the series is when Loghain (who has betrayed his regency and king and is by all rights a textbook villain) is about to be executed, and he turns to his daughter and talks about how she will always be the young girl he bounced on his knee. His actions were not born of some desire to do evil, as we often see in fantasy villains, but rather out of a desire to keep his daughter safe, because he thought there was a much greater threat to the kingdom than the king perceived.

"I find it important to have villains like Loghain, whom we can empathize with, because that empathy helps us to internalize our own emotions and moral conflicts."

To support this approach to narrative, Laidlaw and his team created a gameplay system in which your decisions impact your story. If you feel that the Chantry, the religion within the world of *Dragon Age*, is sinister, you can oppose it. Alternatively, if you feel the actions of the Chantry are just, you can align with it and complete missions for it. You can approach the threat of the Darkspawn as would a traditional hero, fighting them while following the path of righteousness. Or, like Loghain, who committed regicide to further his plan to combat the Darkspawn, you can make morally reprehensible decisions and rationalize that they are for the greater good.

OFFERING CONTROVERSIAL CHOICES

Such an open world results in gameplay options that some players might find controversial. For example, it's possible to engage your lead character in sexual relationships with other characters, and you're free to have an interracial or same-sex relationship within the game. This decision drew criticism, but also much praise. "We have always been committed to the idea of you playing games your way," Laidlaw said. "The gaming community is not a boys' club any longer—it's made up of people from all walks of life. So when we decide to include romance in a story (and we believe romance is a valuable core storytelling element, because it builds an emotional context into the game), we

should enable romantic options for every walk of life.

"Those options can be controversial and make people uncomfortable. I understand that. But as long as we're up front and honest about the content in our games, it's up to you if you want to play them."

Of course, when the game designer allows players to react to the game's characters and story events based on their own

interpretations, predicting how players will respond becomes difficult.

BALANCING PLAYER CONTROL

In games like *Dragon Age*, one player may never visit a certain area, while another might spend hours exploring the location. One player may kill an important character, while another would protect the person. Even while the game gives players agency over their characters, however, it also has to tell a

Promotional art for Dragon Age: Inquisition (BioWare)

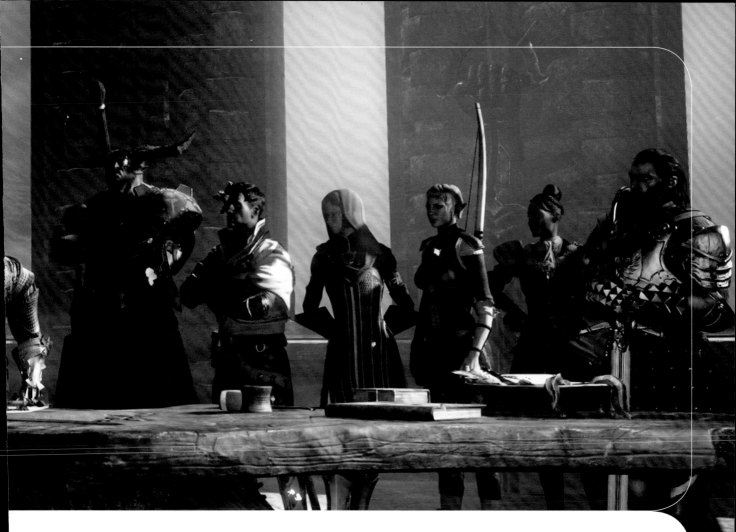

complete story. Laidlaw has had to balance those needs carefully.

"It's not easy working to this kind of narrative structure," Laidlaw said. "The more choices you allow, the less coherent the story becomes. At one extreme, you can go with a perfectly crafted narrative where the player is more combat adviser than participant in the story, as in *The Last of Us* or *Final Fantasy*. In those games, the story is completely coherent, but the characters aren't really yours. And you can't affect the story.

"At the other end of the spectrum is *Minecraft*, which can't tell a story at all, because it celebrates players' pure agency by giving them the tools and a sandbox. But then, *Minecraft* creates watercooler moments where people talk about their experiences in the game and what they did. It is a story—not one the developers told, but a story nonetheless.

"Players have agency to create their own stories and experiences as they go along in *Dragon Age*, but everyone who plays is still headed in the same general direction," Laidlaw said. "I think of it as a wide highway. Our story has a specific path that it needs to follow. We still want to tell that story, but we want people to be able to go about their own way of getting there."

Beyond ensuring narrative flow, making a large game has other challenges, and some of those stem from the need to work on a team.

HELPING OTHERS TO SEE YOUR VISION

Game development offers challenges unlike those of other creative exercises, such as music or painting. "A painting can't be in 3D or move around, unless you're at Hogwarts," Laidlaw laughed. "The goal and challenge for a painter is to capture the essence of a moment in a single image. That's what art is, being able to convey a history of emotion, and the painter has one shot to try to achieve that. In games, technology is our brush, and while we have none of the painter's constraints, we have a whole host of different ones."

The biggest challenge that Laidlaw has found at BioWare is that, as with making a film, creating a blockbuster game is not an individual activity: large teams of people come together for such projects. A creative director's vision guides each team, and the director must ensure that the team understands and shares that vision for it to be fully realized.

"Communication is where things can go right or wrong," Laidlaw said. "I might have a vision, but if I can't articulate it clearly enough that an artist or animator or the programmers can get on board with it, then the idea is doomed to fail.

"Very rarely, you might be able to bruteforce an idea into a game. But any teambased creative work is better when you approach it from the philosophy that you don't force people to saw down trees and hammer them together to make a boat— you make them yearn for the sea."

Opposite and following page: In-game art from Dragon Age: Inquisition (BioWare)

PUSHING
BOUNDARIES

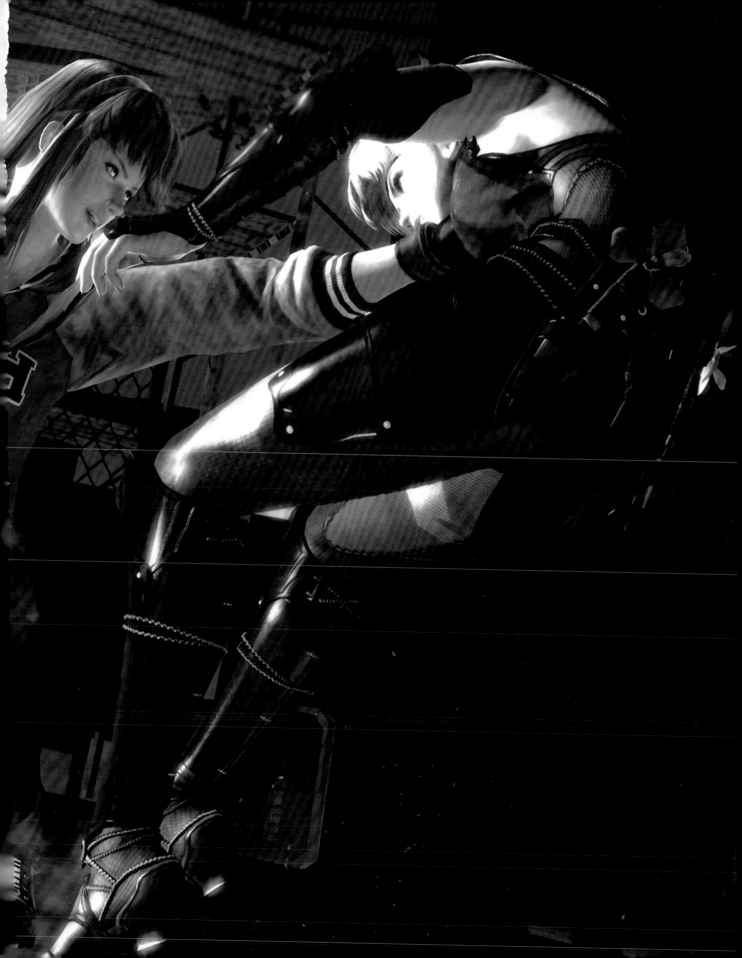

IDEALIZED FIGHTERS AND STYLIZED VIOLENCE

Dead or Alive 5 is an intense, competitive fighting game unapologetically designed to be sexy. It's from a franchise with a history of over-the-top humor. Indeed, under series creator Tomonobu Itagaki's leadership, Koei Tecmo's premier fighting-game franchise was difficult to take seriously (deliberately so), with characters that look like

Previous page: Concept art from Dead or Alive 5 (Koei Tecmo Games)
Above: Concept art from Dead or Alive 5 (Koei Tecmo Games)

YOSUKE HAYASHI
STUDIO: KOEI TECMO GAMES
LOCATION: JAPAN
FEATURED GAMES:
DEAD OR ALIVE 5,
NINJA GAIDEN 3

the hyperidealized plastic mannequins. But when Yosuke Hayashi succeeded Itagaki as the creative lead, he and his team decided to take the series' art in a new direction, with realistic human characters that would sweat visibly, like real martial artists.

"It always struck us as unusual that in a fighting game, the environment would become more battered while the characters would not, creating a disconnect between the characters and the environment," Hayashi explained. "That's why we first decided that we should have a sweat *and* dirt effect, where characters would get progressively dirtier as they fought.

"With the dirt and sweat, we created the impression that the characters were fighting really hard and that they were a part of the

environment around them. From there, it made more sense to have characters that looked realistic."

Thanks to the new artistic direction, however, *Dead or Alive 5* lacks the flashy mechanics common to other fighting games: its combat system focuses on realistic holds and throws and simple strikes. So to keep attracting players, Hayashi and his team were careful to maintain the silly spirit of the series. For example, in a single fight, a woman in a bikini might battle a Russian mercenary dressed as Santa Claus—all to entertain an audience of penguins.

"Compared to the fireworks of a fighting game like *Street Fighter*, *Dead or Alive* is not as visually dynamic, so the humor gives the game a competitive edge in the market," Hayashi said.

"When we thought of the other fighting games out there, we saw this as the identity that would differentiate us from the others," he added. "But another distinctive thing is that the main character is female, which is not that common in fighters."

Of course, sexy characters, both female and male, are a key piece of that identity. And even though they're designed to be humorous, their overt sexuality has brought *Dead or Alive 5* much criticism.

TABOOS

Some Western critics consider *Dead or Alive 5* one of the most exploitative games on the market, but Hayashi insists his team created a game that, in the context of Japanese culture, isn't offensive.

"We definitely didn't want to make something vulgar or in poor taste," Hayashi said. "Yes, the characters are sexy or cute, and we don't deny the personality that we want to bring into the game. We were careful not to cross a line to the point where it would put people off."

Japanese representations of sexuality in games and the sensitivity of Western media to the topic often clash, leading to games like *Dead or Alive*, Platinum Games'

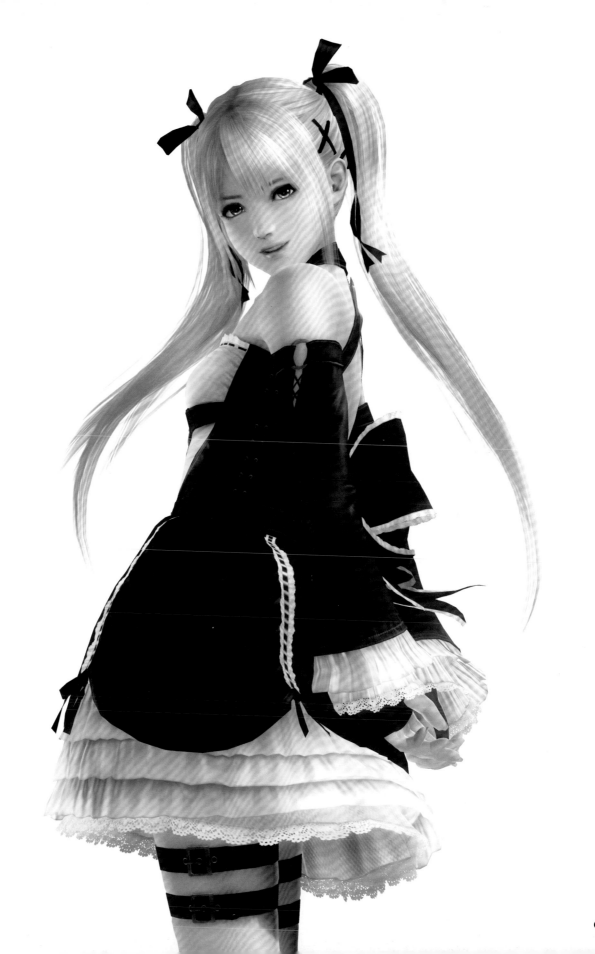

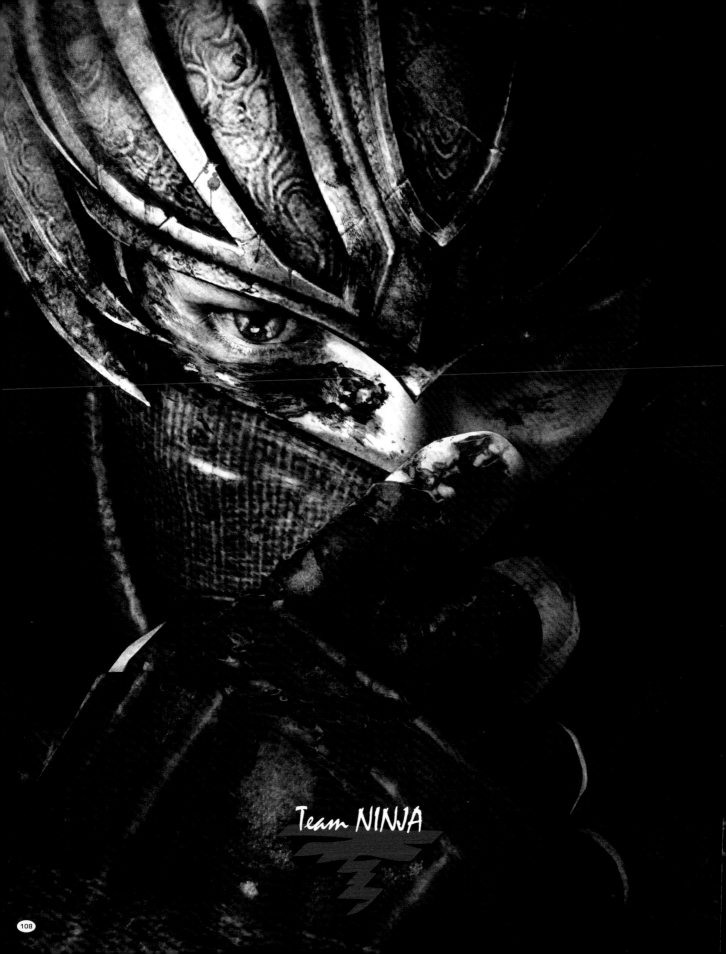

Team NINJA

Bayonetta 2, and Vanillaware's *Dragon Crown* being broadly criticized in the West for their approach to sexuality. But in Japan, these games have been relatively well received.

WHY STYLIZE VIOLENCE?

Hayashi is also the creative force behind the fast-paced, brutal adventure *Ninja Gaiden 3*.

Each game in the *Ninja Gaiden* franchise demonstrates how effective and efficient its lead character—expert swordsman, archer, and superninja Ryu Hayabusa—is at killing, and *Ninja Gaiden 3* is no exception. In Hayashi's take, Hayabusa causes all kinds of extreme mayhem. Bloody dismemberments and fountains of blood erupt from his opponents, reminiscent of an infamous scene in Akira Kurosawa's classic film *Sanjuro*.

Nonetheless, just as Japanese and Western media depict sexuality differently, they also differ in how they show violence. Realistic combat is a staple of Western game development (as evidenced by

popular military shooter games like *Call of Duty* and *Battlefield*), but Japanese games tend toward hyperstylized, even expressionistic violence.

"In Western countries, if a game is more realistic, people find it easier to relate to. From there, they can have an emotional attachment to it, so it can have a greater impact on them," Hayashi said.

"But Japanese people aren't much interested in reading about things that are too close to reality," he added. "Take manga, for example. Manga can be incredibly violent, but it's also imaginative and typically set in fantasy worlds. It can be emotional, but it shouldn't be real. The reader doesn't want to feel like what's going on in the manga could happen to the person sitting next to them."

Still, Hayashi rejects the idea that some topics are off-limits.

"Games shouldn't have taboos. That's why there are age ratings—to ensure that people aren't exposed to content

Opposite and following page: Promotional art for Ninja Gaiden 3 (Koei Tecmo Games)

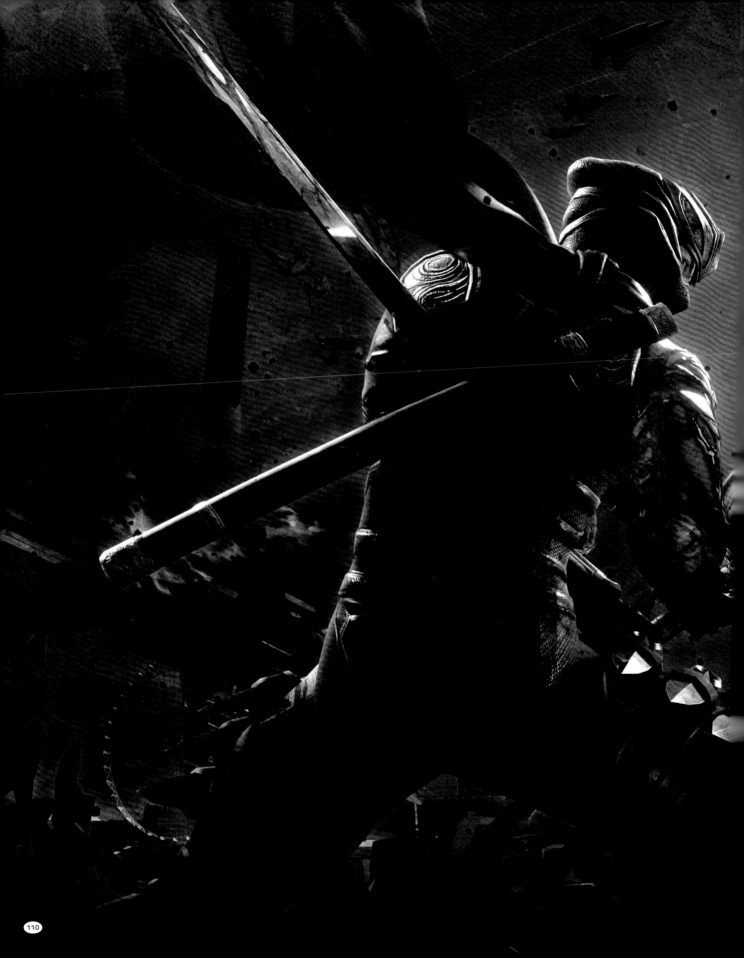

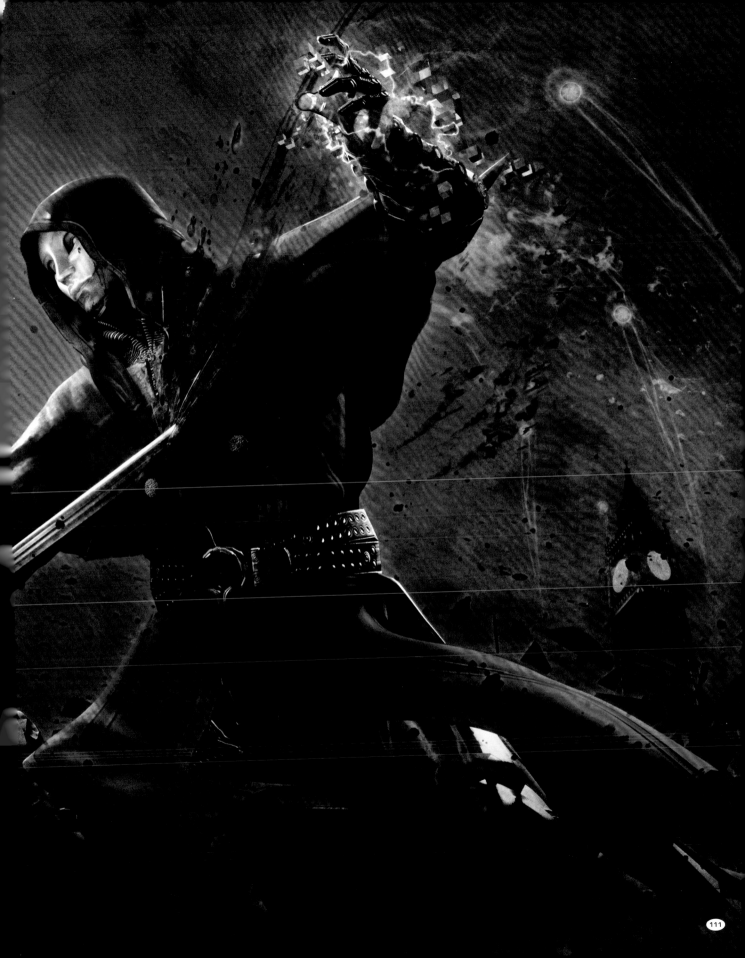

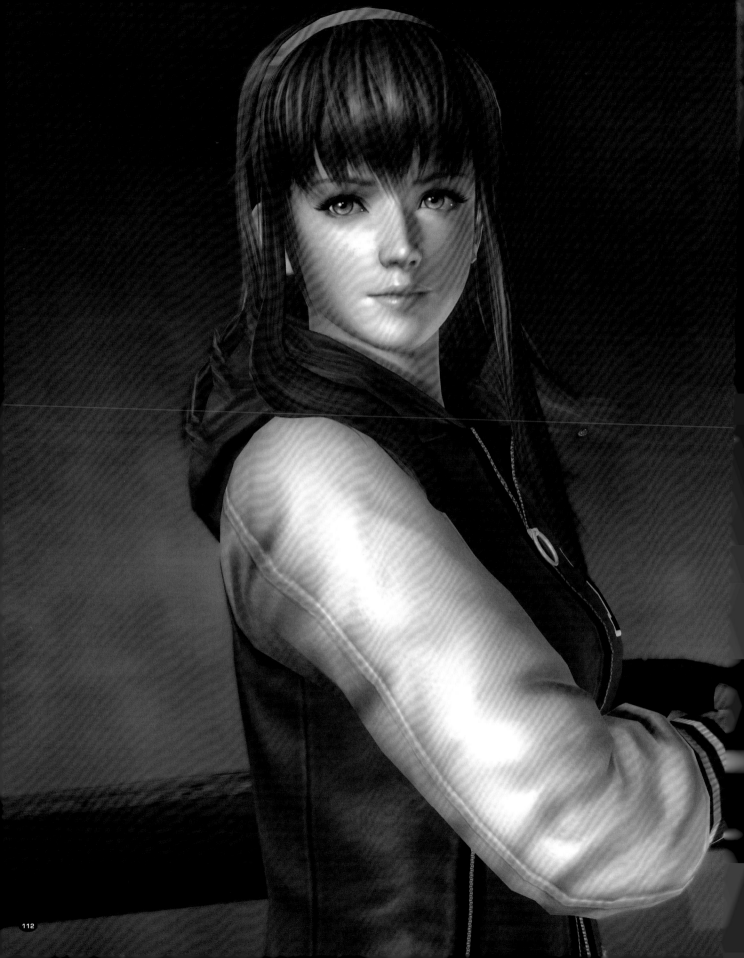

they shouldn't be," Hayashi said. "When I started playing games, they were very much seen as toys for children. But now, adults do play games, and I think we can all agree that having only games that are rated E for Everyone is no longer enough."

Hayashi's stylized and adult work has generated discussion among fans and the media about what games are supposed to be. If one purpose of art is to challenge perceptions and inspire discussion, Hayashi's provocative games certainly fit the bill.

Concept art from Dead or Alive 5 (Koei Tecmo Games)

SEX AND VIOLENCE

Goichi Suda, also known to his fans as SUDA51 (a play on the Japanese words *go* and *ichi*, which mean "five" and "one"), might be the Quentin Tarantino of game development. Suda's games are diverse, but they all push boundaries: they are transgressive, violent, often offensive, and—more than anything—sharply self-aware.

In-game art from KILLER IS DEAD (Grasshopper Manufacture Inc./KADOKAWA GAMES)

Suda's unique approach to game design is clearly inspired by his love of professional wrestling, and his games showcase an epic battle between good and evil that is also completely campy. "I became a game designer because I wanted to make a pro wrestling game," Suda said. "I've always loved video games, but I know this is a serious profession. I knew it wouldn't be easy to break into, so I also applied to become an editor at a famous pro wrestling magazine. I wasn't able to find work at the magazine, but fortunately for me, I managed to get a job at a company called Human, which was famous for its pro wrestling games."

Suda was captivated with how pro wrestling was constructed, like a piece of theater. It's

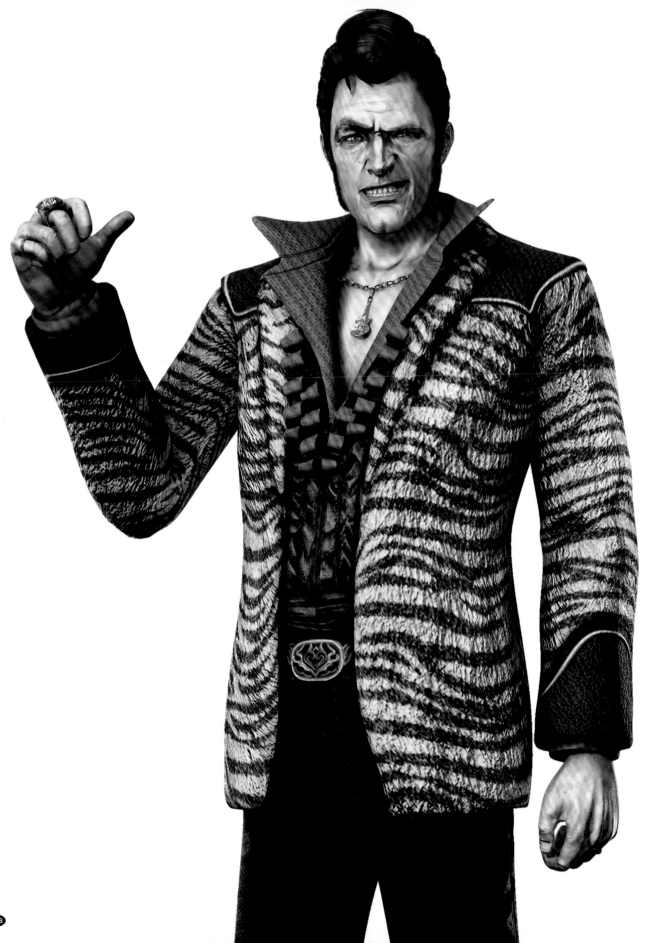

no small wonder, then, that Suda's work has a lot in common with the over-the-top performances that you see in pro wrestling. "I liked pro wrestling not just as sport and entertainment but as an art," he said. "The way the wrestlers move around and present themselves is a kind of performance, and I was captivated."

This passion led to the development of a wide range of games. "I was also lucky because when I started at Human, I was a planner," Suda said, "and that meant I had to keep coming up with new ideas for games. While Human was famous for its pro wrestling games, it always aspired to make other types of games. That philosophy of constantly thinking of new games has really stuck with me."

THE CHEERLEADER WITH A CHAINSAW

Suda now runs his own development team as the CEO of Grasshopper Manufacture, part of GungHo Online Entertainment. As CEO, he's been able to explore his own ideas for game development. While he saw critical success with games like *No*

More Heroes and *Killer 7*, his 2012 game *LOLLIPOP CHAINSAW* was his first global commercial success, selling more than a million units.

LOLLIPOP CHAINSAW is about a teenage cheerleader who happens to be an expert zombie killer. Her weapon of choice? A pink chainsaw. She embarks on a quest to end a zombie invasion led by boss zombies that represent different music genres.

"I've always wanted to make a game about zombies or horror," explained Suda. "But a lot of zombie games intend to be scary, and I didn't want to go there. I wanted to do something along the lines of a B movie. The zombies were a given, so I thought, 'Who should I have kill them?' And I realized that a cheerleader is another staple. Then I needed a weapon. I knew immediately that it could only be a chainsaw," he joked. And Juliet Starling was born.

LOLLIPOP CHAINSAW deliberately inverts the game industry's damsel-in-distress trope in which burly male heroes rescue ladies. In *LOLLIPOP CHAINSAW*, Juliet

Opposite: Concept art from LOLLIPOP CHAINSAW (KADOKAWA GAMES/Grasshopper Manufacture)

does the rescuing. When her boyfriend, Nick, is attacked by zombies, Juliet saves him—by cutting off his head, which remains alive and sentient.

Juliet carries Nick's head around and can compel him to complete mundane tasks for her: she just attaches the head to a zombie body and dances through a cheer routine.

Nick is then used like a tool to push objects out of the way and clear the path for Juliet.

The game is also unusual in that it shames players who have a dirty mind. For example, players who look up Juliet's skirt by adjusting the camera angle "win" an Xbox or PlayStation achievement trophy. *LOLLIPOP CHAINSAW* is clearly aware of its reputation,

Opposite: Promotional art for LOLLIPOP CHAINSAW (KADOKAWA GAMES/Grasshopper Manufacture)

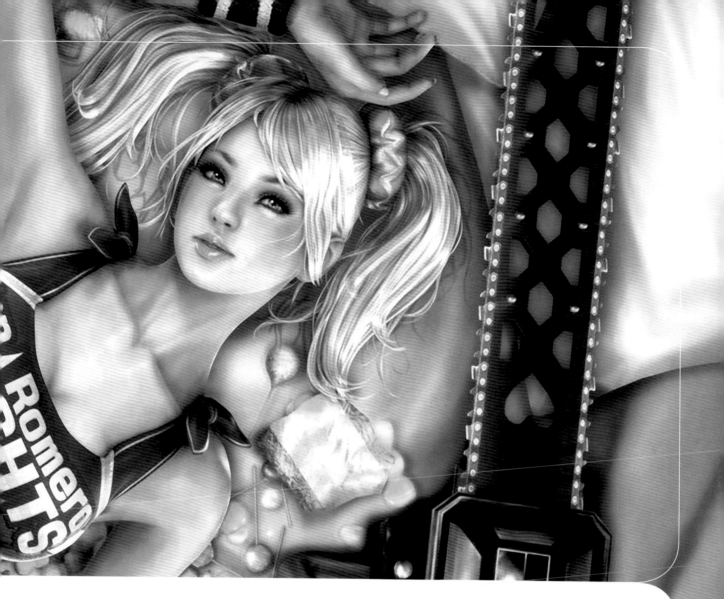

and with details like this, it pushes past expectations to become a transgressive work of art. Of course, not everyone appreciates this style.

"For each game, we need to think, 'Where do we want to position this game?'" Suda said. "Is it going to be a game for everyone, or are we going to go in deep with our themes?

"It's difficult. Sometimes you get the response that you expected from the critics and the community, and you're happy. Other times, you don't. Of course, the goal of any game should be to reach as many players as possible, and I do try and keep that in mind, but sometimes you just want to make a game that goes in deep and offers insights comparable to those that films and novels offer us."

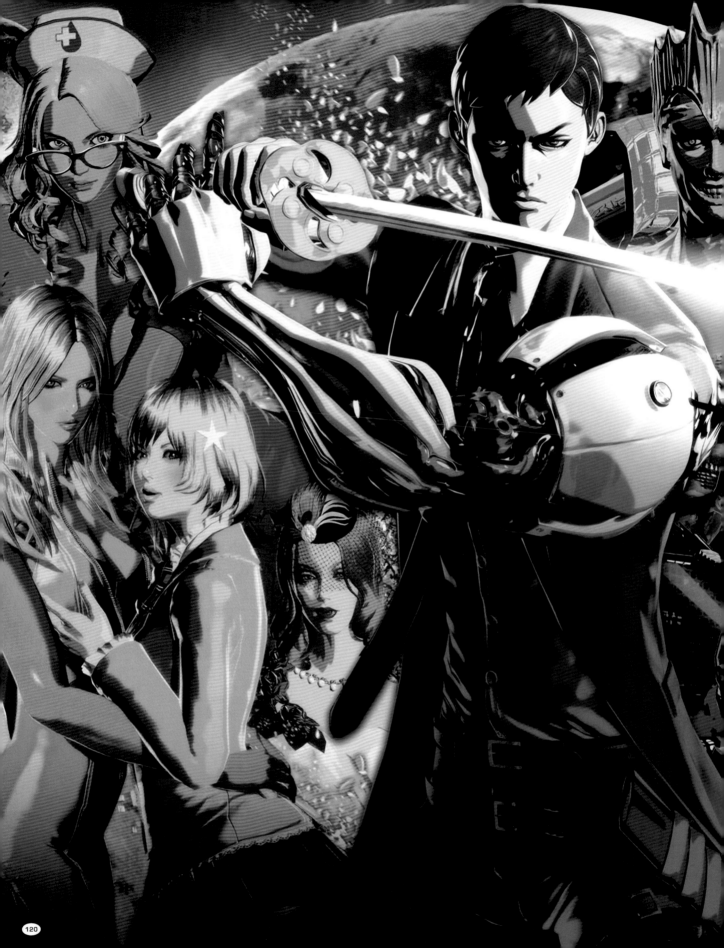

Many argue that art's purpose in the world is to push boundaries. And in *LOLLIPOP CHAINSAW*, Suda does just that, encouraging us to think about how we respond to overt sexuality, damsels in distress, and gender in general.

LIGHT AND SHADOW

Suda's *KILLER IS DEAD* is a hack-and-slash action game in which you, a cybernetically enhanced assassin, execute criminals, and its art style is one of its most distinctive characteristics. Featuring cel-shaded, comic-like visuals, this dark, brooding, violent thriller has aesthetics similar to those of Frank Miller's graphic novel *Sin City*.

This similarity was deliberate, Suda said. "I've always been fascinated by the contrast between light and darkness, and I think it's a timeless theme that applies equally to Japanese and American culture."

The art in *KILLER IS DEAD* centers on that intense contrast. Suda said he wanted to use shadow as a metaphor to explore the darker side of human emotion.

"I wanted everything in the game to seem surreal, or hyperreal, because I wanted to depict a world where you can't see normally. Instead, what you're seeing is the scenes behind the world and the people within it," he said. "I wanted to express the internal battles that people engage with in the world that you never see normally. Everything about the graphics, atmosphere, and gameplay was designed to support that theme, and I think it turned out well."

A GRINDHOUSE COLLABORATION

Suda's grindhouse epic *Shadows of the DAMNED* further demonstrates his creative versatility. In this game, an all-around tough guy named Garcia Hotspur grabs his gun and sets off to rescue his scantily clad girlfriend, Paula, from Fleming, the Lord of the Underworld. In recent years, many film directors have deliberately used the grindhouse genre's tradition of low-quality film stock and cheap special effects to articulate more-sophisticated messages, and *Shadows of the DAMNED* also follows this tradition.

Opposite: Box art for KILLER IS DEAD (Grasshopper Manufacture/KADOKAWA GAMES)

Shadows of the DAMNED is crass and crude, and like Suda's other work, it parodies its genre. But this game was also made before Suda's company was acquired by GungHo, and it represents some of the creative challenges that independent game developers face when they try to make big-budget games. Suda paired up with EA and Resident Evil's creator, Shinji Mikami, to make Shadows of the DAMNED.

"With Shadows, we collaborated closely with EA, and the theme is the end result of the collaboration," Suda said.

Despite the inevitable creative differences that arise when creators work together, Suda expressed positive feelings about creating games with publishers. "Some things can be frustrating with publishers, but at the same

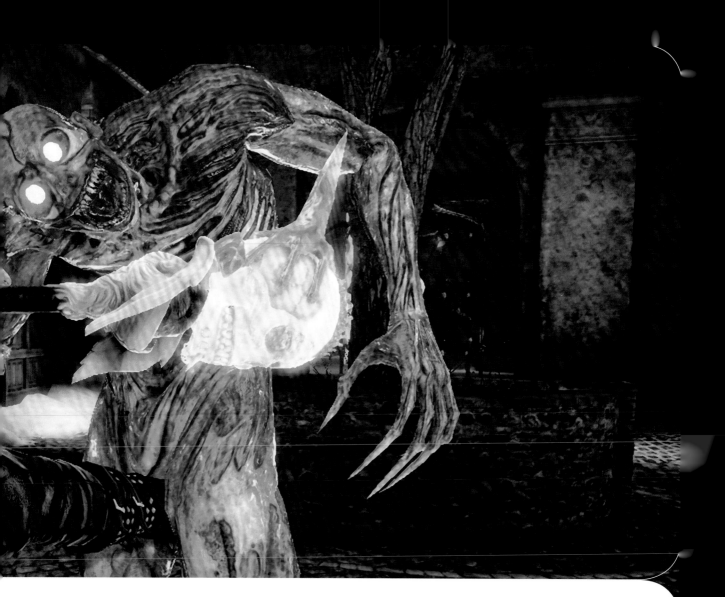

time, you're somewhat protected in terms of the financial considerations.

"And ultimately, we're all there for the same reason. Most publishers are there to make sales and profits, but as developers, we also want as many people to play our games as possible. So the goals are really the same, even if they are stated differently. Overall, it's been a very good experience working with publishers."

Suda shows no sign of slowing down. While other game developers may find themselves typecast into certain genres, one thing you can be sure about Suda is that you will never guess what game he is working on next.

Previous page: Concept art from KILLER IS DEAD (Grasshopper Manufacture/KADOKAWA GAMES)
Above: In-game art from Shadows of the DAMNED (Grasshopper Manufacture Inc.)

EPIC QUESTS
AND
EVERYDAY
LIFE

PARODY WITH CUTE CHARACTERS

A subsidiary of Idea Factory, Japanese developer Compile Heart is known for *Hyperdimension Neptunia*, *Fairy Fencer F*, and other zany JRPGs that feature cute female lead characters. But some of Compile Heart's most popular and lucrative franchises are also infamous for sexualized scenes that push the boundaries of good taste. One of the most common complaints about *Hyperdimension Neptunia*,

Previous page: Concept art from Fairy Fencer F (Compile Heart)

NAOKO MIZUNO AND TSUNAKO
STUDIO: IDEA FACTORY
LOCATION: JAPAN
FEATURED GAMES:
FAIRY FENCER F,
HYPERDIMENSION NEPTUNIA

for example, is that it's an exploitative series, surely designed by men for socially awkward teenage boys. *Sexist* and *perverted* are adjectives you'll often see in reviews of these games.

Given their reputation, however, you might be surprised to learn that *Hyperdimension Neptunia* and *Fairy Fencer F* were in fact created by a tag team of female artists: producer and creator Naoko Mizuno and character designer Tsunako.

Above: In-game art from Fairy Fencer F (Compile Heart)

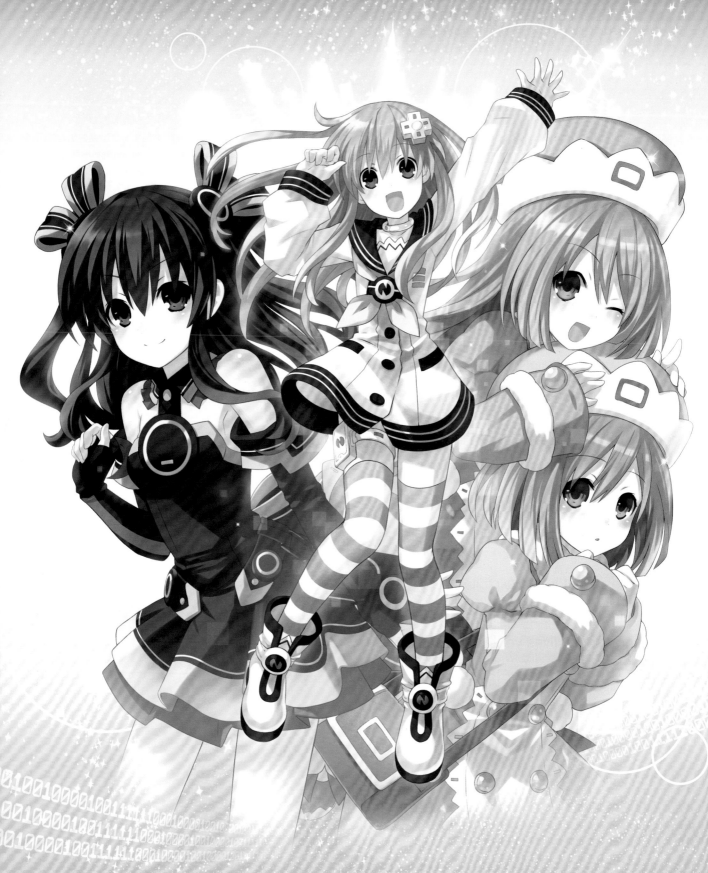

These games aren't intended to be exploitative; instead they seek to parody the exploitation found in the games industry.

Mizuno has always been interested in exploring comedy and parody in games. "I much prefer making comedic games. I love to laugh, and I think I'll leave the development of serious games to the creators who are good at making them," Mizuno said while laughing. "If I were to try to make a serious game, by the time we released it, it would probably be the funniest one I'd ever made."

Her most popular work, *Hyperdimension Neptunia*, is a trilogy of JRPGs that imagines the games industry as a fantasy world. In this world, the industry's big-time developers are nations, and each of the consoles is a cute girl. These girls go on quests that ridicule everything from how the games business works to how fans behave. While lighthearted and silly, these games are still real critiques of the games industry.

For example, by personifying game consoles as *moe* (cute) female characters, Mizuno and Tsunako were able to explore the way that the games industry creates and sells its products.

DEVELOPING CHARACTERS

"When I was designing these characters, I tried to pick up on each of the console's distinctive features, such as its color and shape," Tsunako said. "I couldn't copy the hardware entirely, of course, but I tried to see the design of the consoles like I was looking at them from very far away."

To complement Tsunako's designs, the characters' personalities parody the consoles' reputations. The character based on the Xbox, Vert, tries to act mature, but you discover that she's just as juvenile as the other characters. In this way, the game pokes fun at the idea that the Xbox is a "mature" console. The character representing the Wii is affable

toward children but turns a cold shoulder to anything that isn't family friendly, teasing Nintendo about its tendency to strip out all and any adult content from its games.

But why the overly cute characters? Tsunako said that she missed out on a lot of the "classic" JRPGs as a child, so they just don't inform her style. Without their influence, she developed her own approach to character design—and she just happens to like cute things.

"I never really played the more serious fantasy games that were popular when I was growing up," she said, "And from a young age, I was more interested in the *moe* art style instead of the kind of anime and manga that young girls would generally read and watch. As an adult, I was actually more inspired by the kind of art that was for boys, and I wasn't really inspired by the kind of art styles that are traditional in games. So I started to draw *moe* characters. These designs were popular, and from there, I decided that it would be my style of work. I was fortunate that it fit well with the theme of *Hyperdimension Neptunia*."

FINDING A BALANCE

According to Mizuno, this art style has also allowed the development team more freedom in its satire. Because the cute characters are difficult to take seriously, there's less risk of offending the developers and publishers the games lampoon. This is true in Japan, at least, where the culture predisposes people to relate to this sense of humor.

"It's a delicate balance to strike when you're making a series about the games industry itself," Mizuno said. "From the first game, we've been asking ourselves, 'Where do we draw the line?' We don't want to compromise our vision, but at the same time, the only reason we can continue to make these games is that we're making people laugh and be happy. We can't produce the kind of parody that offends if we want to make this a long-running series."

By exploring the politics of the games industry through the design of the game and personality of its characters, Mizuno and Tsunako have created a series that is not easily dismissible as mere exploitation. *Hyperdimension Neptunia* parodies intentionally, making fun of the very same qualities that some criticize it for having.

FENCING WITH FAIRIES

After the *Hyperdimension Neptunia* series, Mizuno and Tsunako teamed up again, this time on *Fairy Fencer F*.

While lighthearted and comedic, *Fairy Fencer F* is a little less ridiculous than *Hyperdimension Neptunia* and is grounded in a traditional JRPG framework. In this game, players control a male hero who has pulled a sword out of a rock, Excalibur style. But as it turns out, this sword is actually a female fairy. Together, the hero and the sword fairy set off on a quest to find and help other fairies and their wielders.

Fairy Fencer F is also much more focused on human relationships than is *Hyperdimension Neptunia*. The game often explores the close ties between fencers and their fairies in touching ways, and it emphasizes how individual identities and different personalities help both people in the relationship succeed. For example, one core mechanic involves the sword fairy impaling her human fencer to increase their attack and defense. It's a simple but effective metaphor for the way that relationships are strengthened by absolute trust and openness between two individuals.

Although she enjoys creating lighthearted games, Mizuno said it's not easy to continue to come up with funny scenarios. "As the producer, having so much information to work through makes me feel like my head will explode at times!" she laughed. "I actually started out as a 3D designer before having the opportunity to produce the *Hyperdimension Neptunia* series, and when I started producing games, I found it bewildering to differentiate between the work of a designer and that of a producer.

Opposite: In-game art from Fairy Fencer F (Compile Heart)

"Thankfully the staff here have been so supportive and helped us come up with such different games as *Fairy Fencer F*," Mizuno added. "I'm very proud of what we've been able to achieve."

CRAFTING NEW CHARACTERS

While Mizuno deals with scenario challenges as a producer, Tsunako faces her own hurdles. She develops fresh characters for as many as four Compile Heart games each year, and constantly designing new characters isn't easy.

"Of course, it's very difficult to keep coming up with new character designs," Tsunako said. "But as the character designer, I get to work to a brief, and that helps. I'm provided with the scenario and each character's personalities, and then I start to think how the design can suit that personality.

"I've been lucky so far that I've been of the same mind as the people I've worked with," she added. "I've been able to simply read the scenario and propose original ideas for characters that have worked for the end game.

"But I don't think I've created my best work yet. I have a deep affection for the *Hyperdimension Neptunia* characters, but I'm a perfectionist. That said, if even one person appreciates and enjoys the games I work on, then I believe my work has been a success."

BUILDING NEW WORLDS

In 2011, Japan was rocked by a 9.0-magnitude earth-quake, followed by a massive tsunami that hit the northern region of the country. The tragedy, which devastated entire cities and severely damaged the now-infamous Fukushima nuclear power plant, claimed the lives of close to 16,000 people and injured over 6,000 more.

Concept art from Atelier Totori (Koei Tecmo Games)

YOSHITO OKAMURA
STUDIO: KOEI TECMO GAMES
LOCATION: JAPAN
FEATURED GAMES: ARLAND
AND DUSK TRILOGIES FROM
THE ATELIER SERIES

This disaster shook the people of Japan profoundly, including the artists behind the long-running *Atelier* series by GUST, a subsidiary of Koei Tecmo Games. In turn, this emotional shock affected the development of the games, according to director Yoshito Okamura. Just before the earthquake, GUST's developers had completed *Atelier Meruru: The Apprentice of Arland*, which finished the popular *Arland* trilogy, and they were planning their next trilogy. Okamura said his team has always tried to approach each new series of *Atelier* games with a different central theme. Following the earthquake, they decided to explore the disaster's effect on the mindset of their entire nation.

Following page: Concept art from Atelier Shallie (Koei Tecmo Games)

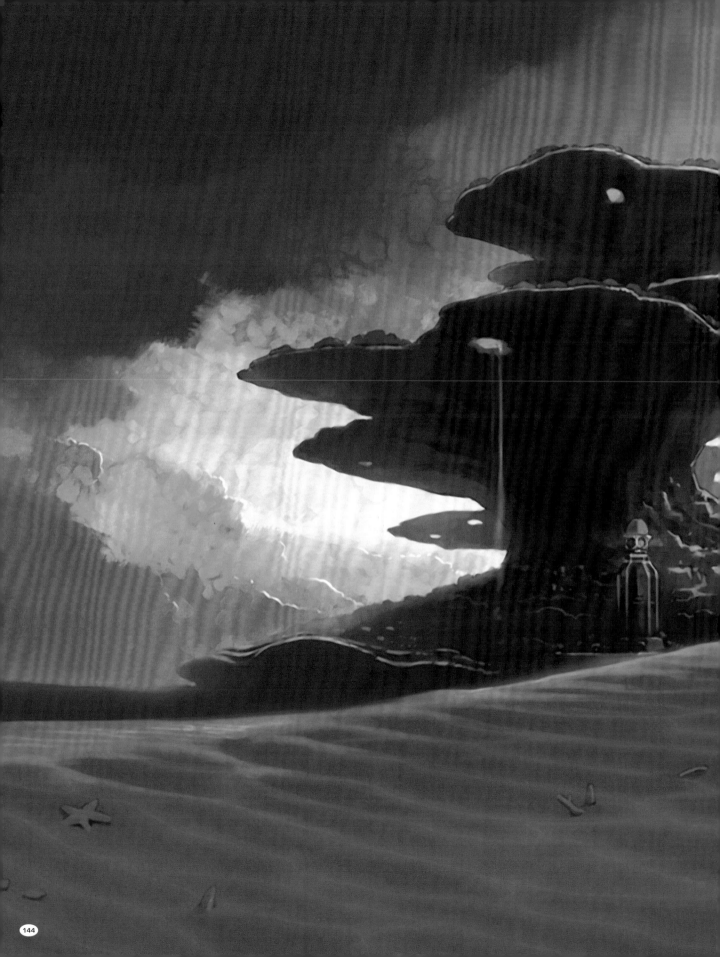

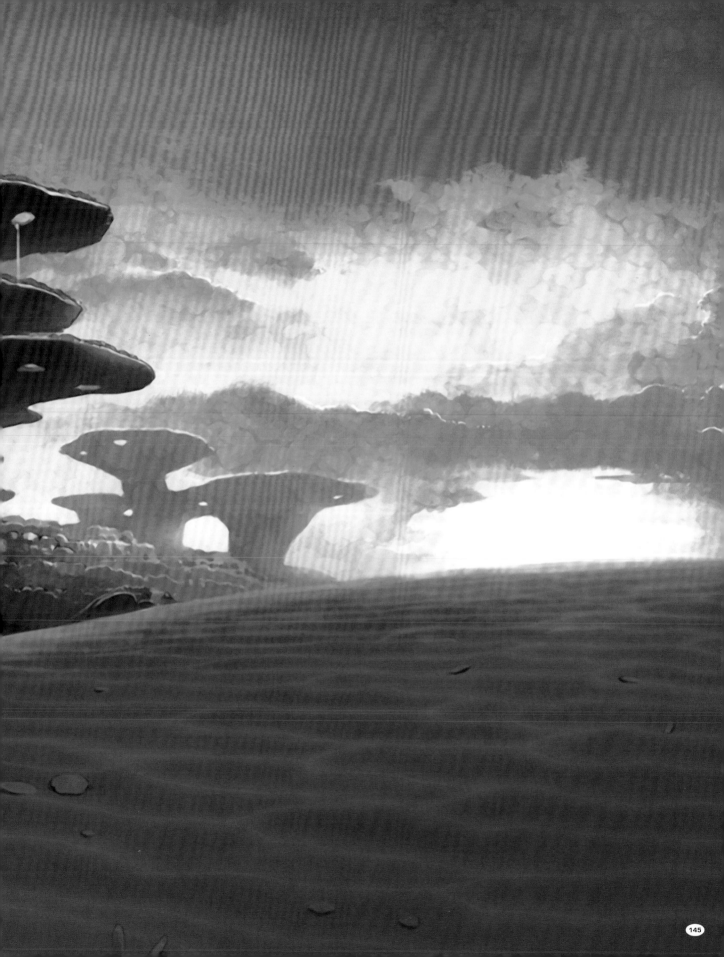

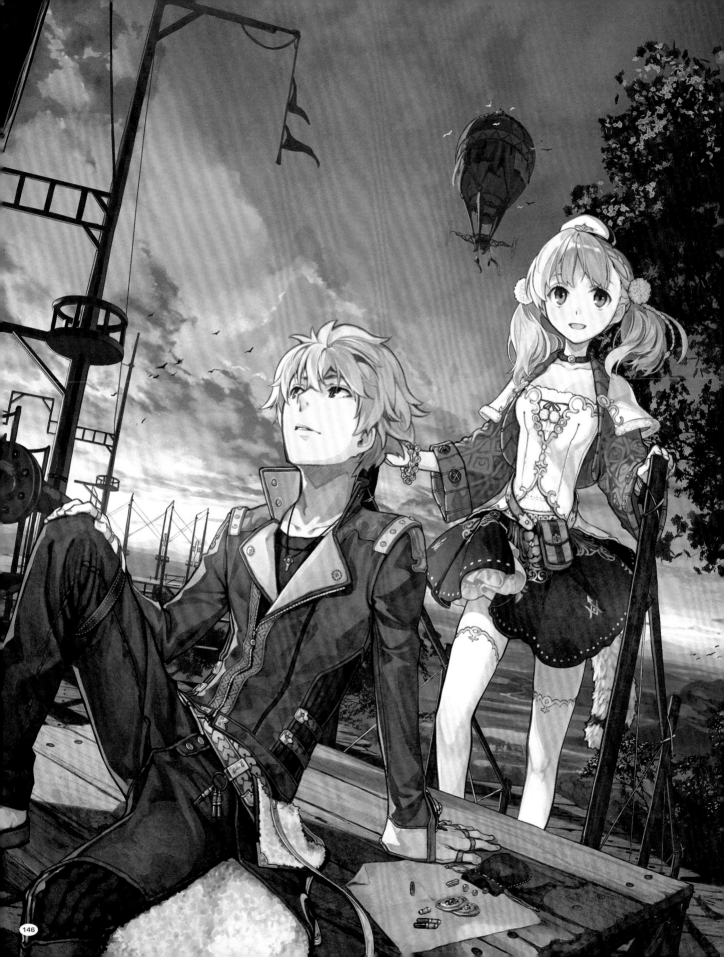

"The three *Arland* games were very successful for us, but we felt that we should take the new franchise in a more serious direction, because the *Arland* games were very bright and cheerful," Okamura said. "As we were designing the first game of a new series, the earthquake and tsunami that all of Japan experienced were profound reminders that we should not take anything for granted and that in life, our expectations can fall through."

The result was the *Dusk* trilogy, consisting of *Atelier Ayesha: The Alchemist of Dusk, Atelier Escha & Logy: Alchemists of the Dusk Sky*, and *Atelier Shallie: Alchemists of the Dusk Sea*. These three games stand out visually and thematically from other entries in the *Atelier* series, especially the colorful *Arland* trilogy, because in *Dusk*, the world is slowly dying. The artists employed muted colors, harsh environments, and sad music to create a desolate atmosphere, and it feels as if there's little anyone can do to save the world from its death throes.

Yet in the midst of this apocalypse, the characters in the *Dusk* games continue to function as a society. Much as the Japanese did after the 2011 earthquake, they stoically go about their lives, working together to make the most of the hand fate has dealt them.

"We wanted to contrast the darkness of the *Dusk* theme with the *Atelier* franchise's traditional core idea that people can work harmoniously together," Okamura said. "In the *Dusk* series, not every day is a good day, and happiness is neither an entitlement nor a promise.

"But," he added, "despite the fact that the people are living in such desolation, they somehow pull through as a group. People are still happy and understand that they're the fortunate ones."

KEEPING WITH TRADITION

Despite the change in tone from *Arland* to *Dusk*, some traditions have persisted throughout the *Atelier* series, giving players

Opposite: Promotional art for Atelier Escha & Logy (Koei Tecmo Games)
Following page: In-game art from Atelier Meruru (Koei Tecmo Games)

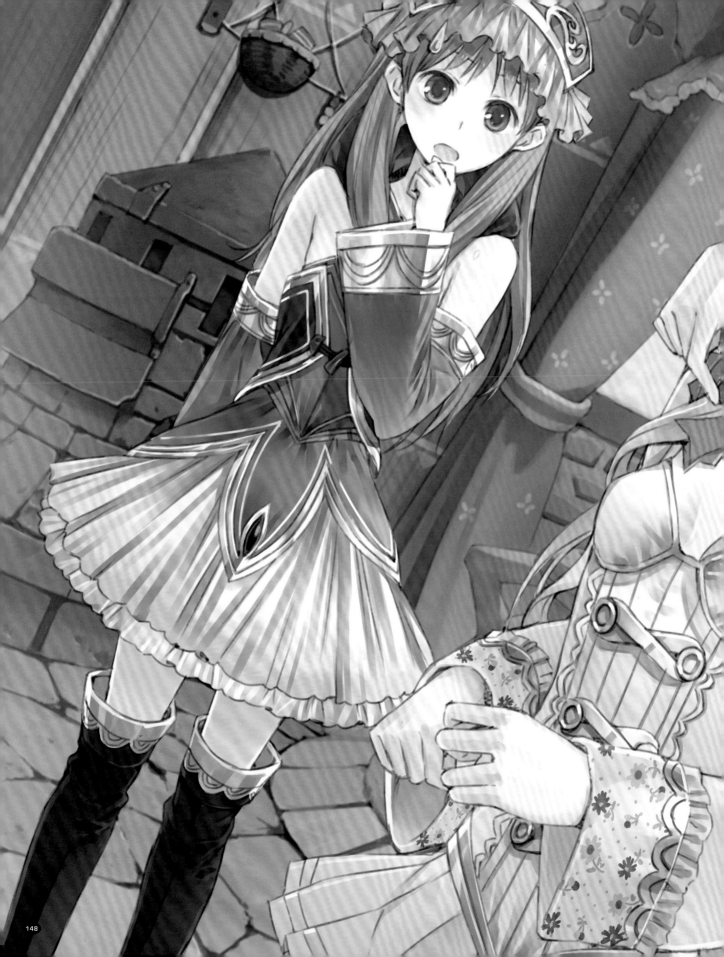

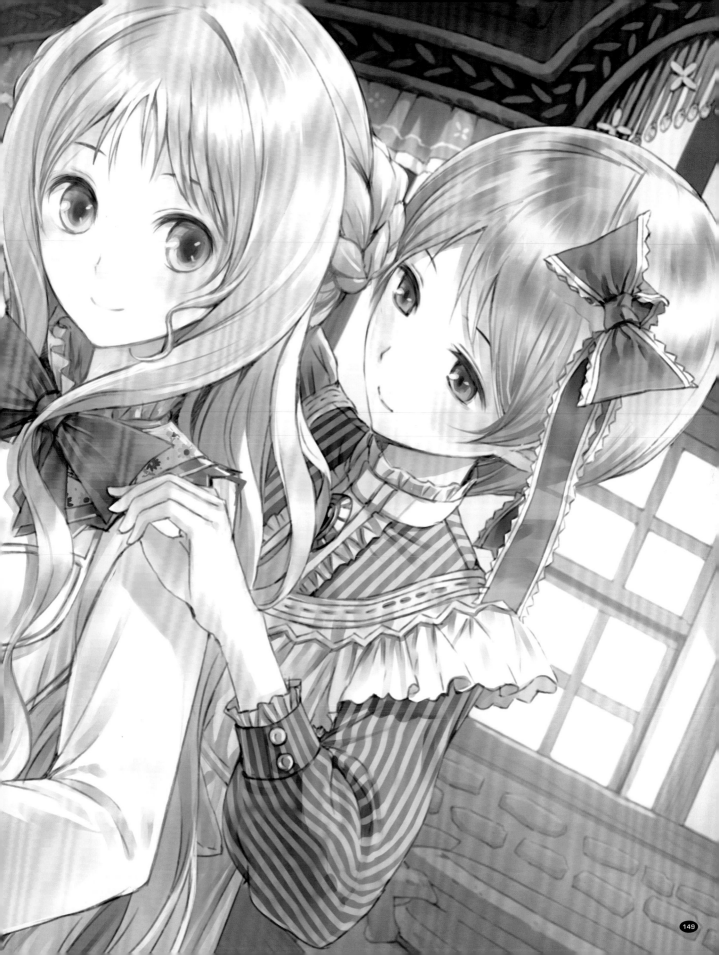

a sense of continuity across the games of their beloved franchise.

When the main character in any *Atelier* game sees a barrel, she yells, "*Taru!*" (Japanese for "barrel"). This action is just a charming quirk with no real in-game significance. Still, it's become so much a part of the game experience that longtime fans of the *Atelier* series look forward to it.

"The tradition started with the first title [*Atelier Marie*, 1997], and it was simply something that one of the programmers had been playing with. We had such fun with it that we put it in," Okamura laughed. "The ability to interact with objects in the game was important, and *taru* was cute and fun for the players. So we've kept it in the series as an in-joke ever since."

Only a handful of the 16 games in the series feature male leads, and the series is well regarded for being one of the few JRPG franchises to feature female lead characters that are not sexualized or exploited specifically to cater to male players.

"We wanted to create a series that both men and women can enjoy equally," Okamura said. "Even now that there are more JRPGs with female lead characters, one thing that we're trying to do to differentiate ourselves is to not make the girls too cute (*moe*) or sexualized. Hopefully, by not going to any extreme, we can appeal to everyone."

Many of the appealing features of the *Atelier* series have been inspired by Okamura's own experiences playing games.

A DAY IN THE RPG LIFE

Okamura has spent his entire career with GUST, but his drive to develop games began with the very first ones he played.

"When I was playing the Famicom, being able to control a character and interact with the world really attracted me," Okamura said. "I also enjoyed reading, and any activity that uses the imagination that would really make me think. I grew up on games like *Wizardry* and *Ultima* for that reason.

Opposite: Box art for Atelier Rorona (Koei Tecmo Games)

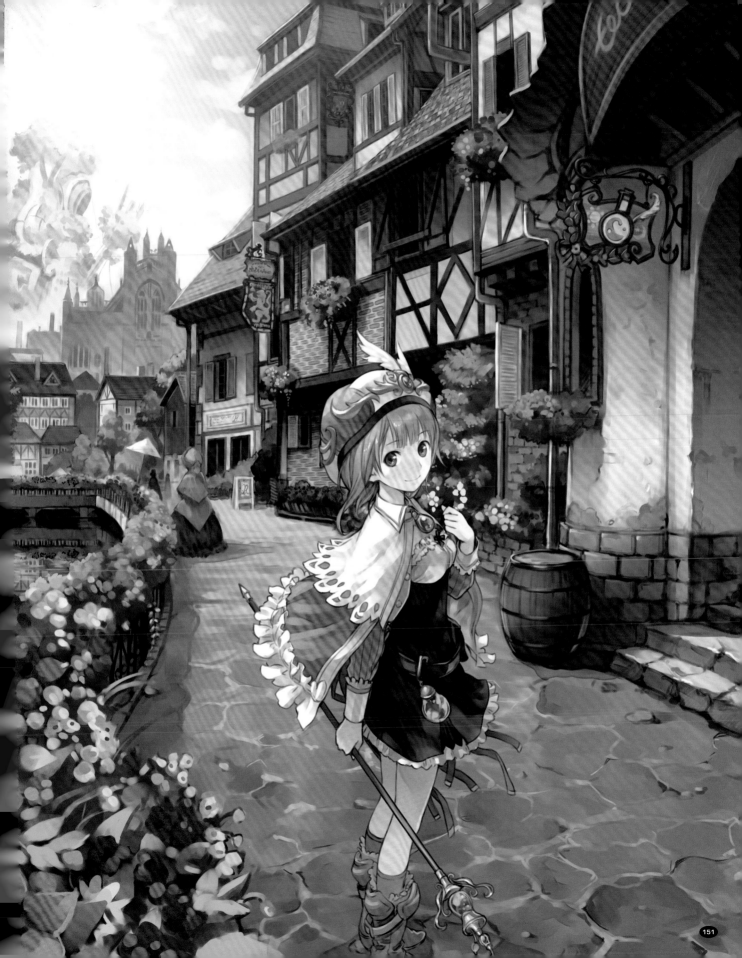

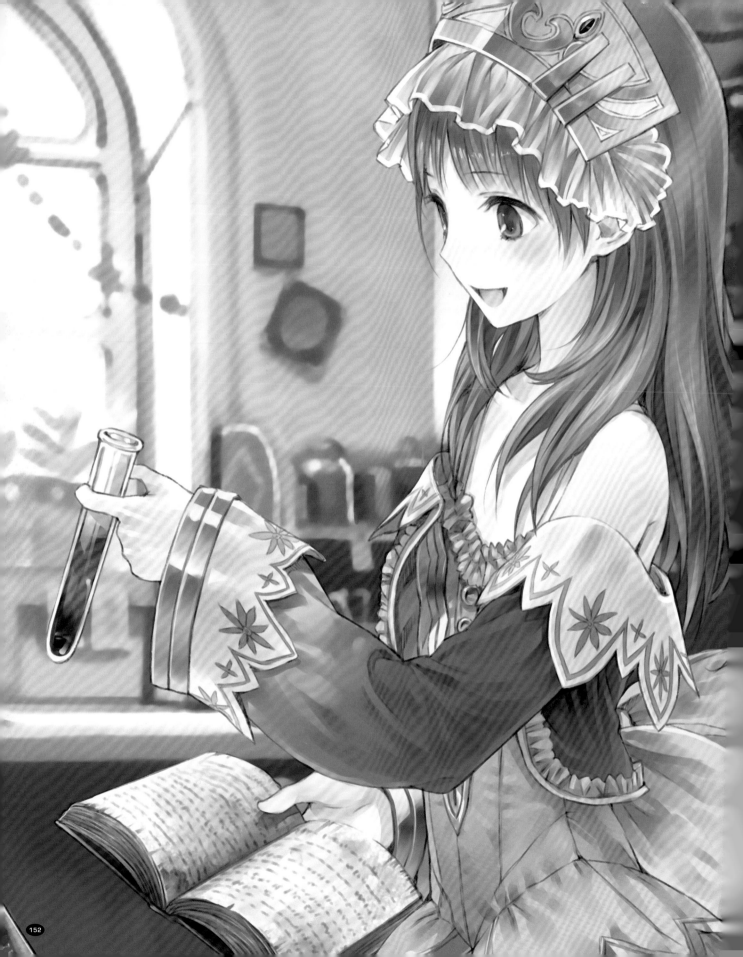

"Then I started to think about how I would like to see the stories in these games evolve, and from then on, I always had the intention to become a game creator."

These days, Okamura is as inspired by Western RPGs as he is by other JRPGs. He's particularly attracted to the open worlds of games like *Skyrim*, *Mass Effect*, and *Dragon Age* because of the amount of control that they give players over the story, though he realizes that what makes *Skyrim* great might not work in his games.

"To a degree, I would like to take some elements from *Skyrim* and implement them in *Atelier*," Okamura said. "Perhaps we could do something that is not exactly like *Skyrim* but rather borrow elements from it and use them in a way that Japanese players would enjoy. For example, we could have the freedom of *Skyrim*, but from the Japanese point of view, we couldn't have the same extensive and violent combat. Our fans play our games, in particular, because they want the experience of characters helping others and banding together with others to achieve things."

Over the years, the *Atelier* series has become Okamura's baby in a way that few game developers ever experience. But while he's on the lookout for ways to keep the series growing and evolving, at its core, *Atelier* still follows a remarkably simple and innocent concept.

"What differentiates *Atelier* from a lot of the other JRPGs is that those games have huge end goals and epic challenges that need to be defeated," he said.

Though *Atelier* is a JRPG series, Okamura said he'd liken it to lighthearted farming simulator *Harvest Moon* rather than JRPG stablemate *Final Fantasy*. The *Atelier* games are about more than just combat and adventure, and in fact, players are often tasked with simply living the characters' lives.

"With *Atelier*, we want to our players to connect with the characters," Okamura said. "Like most of us, in their day-to-day activities, the characters in the game are more concerned with achieving small personal goals than with changing the world."

LAUGHTER AND ABSURDITY

Idea Factory is a developer and publisher known for creating unique and, frankly, odd games. From weird and wonderful JRPGs such as *Mugen Souls* and *Hyperdimension Neptunia* to visual novels like the *Hakuouki* series, Idea Factory games run the gamut of styles and themes, and artist and designer Makoto Kitano has produced some of the company's strangest titles yet.

In-game art from Sorcery Saga (Compile Heart/Zerodiv/D4Enterprise Co., LTD.)

As part of Compile Heart, a development team within Idea Factory, Kitano is best known for *Sorcery Saga: Curse of the Great Curry God*, a JRPG whose core mechanics are based on cooking and eating curry, and *Monster Monpiece*, a strategy digital card game with some cheeky, even lewd mechanics. And while these games play like nothing else you've ever seen, Kitano said he typically gets his ideas from very simple places: sometimes, a single word or concept is all it takes to spark a full-featured game.

"With *Sorcery Saga*, we were making a spiritual sequel to the *Madou Monogatari* series," Kitano said. "Within those games, *curry* was a key word that was used regularly . . . and I thought it was an absurd enough word to

turn into a humorous narrative. After all, this is a JRPG where players fight a lot of monsters, and so I thought it would be funny if the defeated monsters turned into veggies and ingredients to cook with. You eat the curry, power up, and then go forward into tougher fights."

Sorcery Saga is a roguelike RPG. In a roguelike, you control a single character, and the goal is to delve deeper and deeper into a dungeon. If your character dies, the adventure is over: you're sent back to the beginning of the dungeon, losing all your experience and treasure. All those hours of play time are irrevocably lost—all you can do is start again.

Repeating the same adventure over and over may sound dull, but with their high stakes, roguelikes can offer the determined player a fun challenge. Unfortunately, they're also often nearly impossible to finish and so, according to Kitano, are too frustrating to appeal to a wide audience. He and his team sought to make *Sorcery Saga* a game that everyone could enjoy.

To that end, they tweaked this Sisyphean gameplay, allowing you to keep some items and save your progress when a monster gets the better of you.

That desire to make games with the player in mind drives Kitano to embrace creative input from his entire team.

EMBRACING THE TEAM'S CREATIVITY

As a producer, Kitano assumes ultimate responsibility for the games he works on. As a leader, however, he prefers to solicit as many opinions as possible. One of the benefits of creating absurd, humorous games is that you can mix and match some very odd concepts and still wind up with a game that works.

"Everyone on our teams gets input into some of the crazy ideas that we come up with," Kitano said. "Illustrators, scenario creators, sound designers, and others all have their input, and then we pick a mix that will have the biggest impact on our target consumers, something we think they will think is fun.

"I believe it's my job as a game creator to judge and package together lots of different ideas for the benefit of the consumers. And for our audience, that means some pretty crazy things!"

Focusing on your consumer can lead you down some strange roads. *Monster Monpiece* is arguably even more bizarre than *Sorcery Saga*. It started out as a serious fantasy card game in which players collect cards representing various monsters and then summon those monsters to battle opponents. But Kitano felt that it lacked the "Idea Factory identity." To add a twist, instead of designing traditional monsters, he and his team created female characters as mythological creatures. The "monster girls," in typical over-the-top Japanese style, are dressed provocatively and often have huge weapons.

It's clear that one of the goals of this digital card game's developers was to make lovely and unique art. Kitano's history in the animation field is readily apparent. But this sexually charged game is undeniably designed for adults.

Monster Monpiece is a game for the PlayStation Vita, a mobile gaming console with both a front and back touch-sensitive screen. To increase a monster's power, the player must rub both screens in a highly suggestive manner. When a monster girl levels up, she gains new powers—and also loses her clothes.

Unsurprisingly, this mechanic was met with much criticism. Some critics found it exploitative, and many players found it simply too juvenile or embarrassing to play. Some of the most sexually explicit artwork in the game was removed in the Western release of the game, but the studio never-theless rated the game as 17+ even there.

At the same time, Kitano aspires to convey a serious message in his games.

"There's a story to the game, and we do have a commentary to make," he said. "It's a story of bonds between the humans and the monsters, and we make a statement about how racial relations work in society.

"Ultimately, though, we keep our target audience in mind at all times," Kitano

added. "The key words and themes that we come up with for our games are important at the starting point, but if we don't create something interesting for our players, then it's just egoism. We don't want to be selfish developers."

Although Kitano is guiding the direction of his games now, he hasn't always been in a leadership role. Early in his career, Kitano focused only on artwork.

FROM ANIMATOR TO PRODUCER

Kitano's educational background was in animation, which he said provided a smooth entrée into the games industry.

"I originally wanted to get into animation," Kitano said. "But I also got interested in games when I realized that, as an animator, I would have the opportunity to build them from the very early stages of game development.

"I've been working in games since the Super Nintendo, where I was animating, but I realized that I wanted to move past the visual art of games, and that's when I realized I wanted to move into game design as well."

Kitano said he's also drawn to game design by a deep love of RPGs. "I really like dark games, which is strange given the games I make these days," he laughed. "But one thing I like to see in any game I play or make is a game that pushes boundaries and creates standout characters."

Varied as Kitano's games are, they do indeed have standout characters—and they certainly push all sorts of boundaries.

Promotional art for Monster Monpiece (Compile Heart)

MICROBUDGET
GAMES

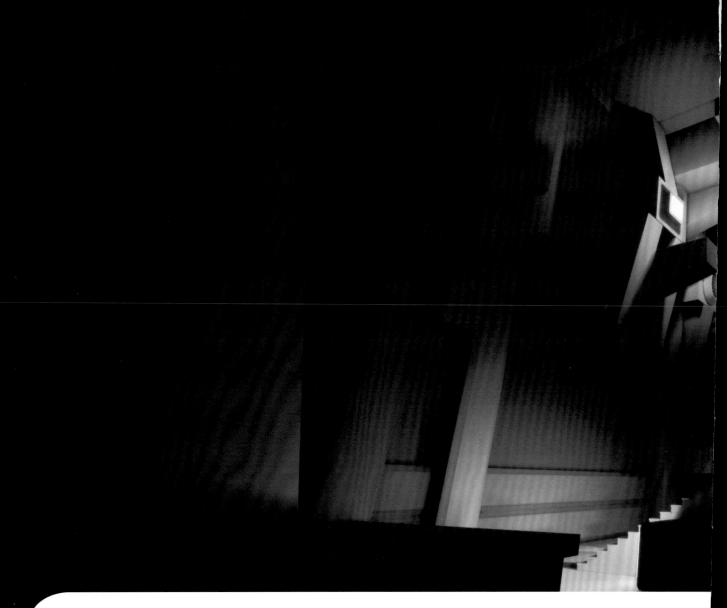

ROOTS IN FILM

Independent developer Mavros Sedeño originally planned to work in film, but that was before he started developing games. He participated in a group effort to release *Perfect Dark Source*, a fan remake of the Nintendo 64 classic *Perfect Dark*, using the *Half-Life 2* engine. This process of changing (or, in Sedeño's case, completely

Previous page and above: In-game art from NaissanceE (Mavros Sedeño)

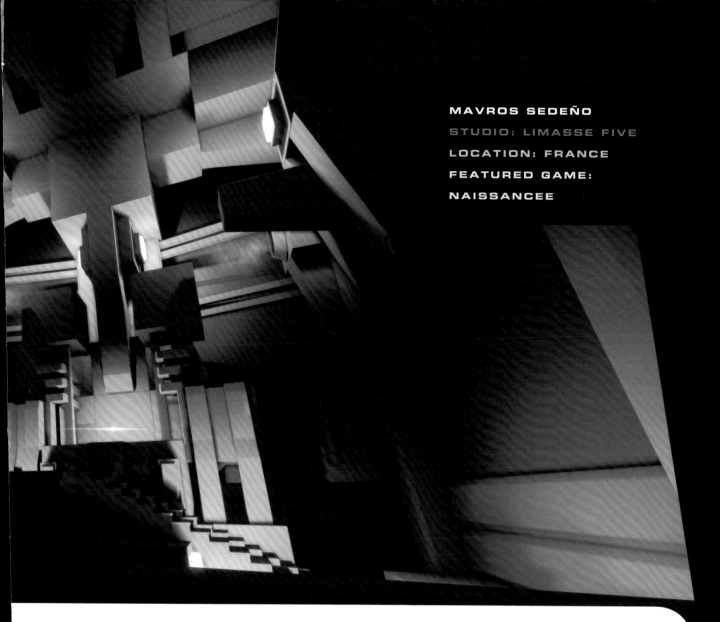

MAVROS SEDEÑO

STUDIO: LIMASSE FIVE

LOCATION: FRANCE

FEATURED GAME:

NAISSANCEE

overhauling) an existing game to bring one's personal vision to life is called *modding*.

"That experience taught me a lot about the process of game development and working with a team on a project," Sedeño said. "The *Perfect Dark Source* team was geographically dispersed, but collaborating online provided me with the skills I needed to create my own games."

His creative arts background and love of film were also great sources of inspiration. "I'm a big fan of cinema," he said, "especially films such as *2001: A Space Odyssey*, *Cube*, *Blade Runner*, and *Dark City*."

Sedeño was drawn to becoming an independent game developer by the unique artistic opportunities it offered, and his favorite

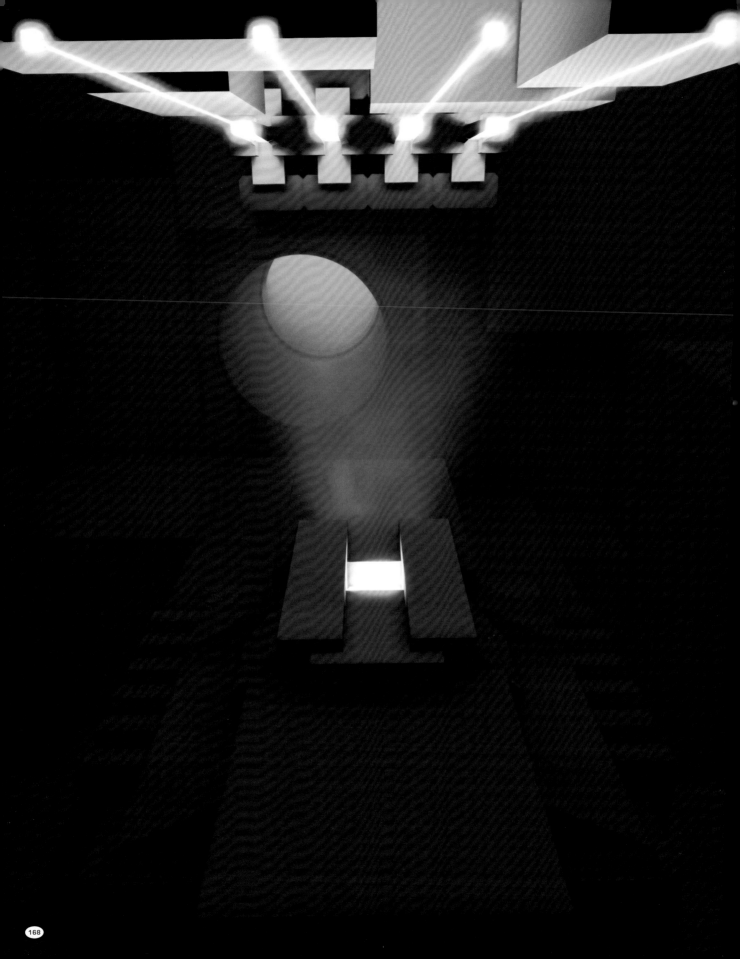

films were major influences on his first commercial project, *NaissanceE*.

However, developing video games opens up creative possibilities not accessible to filmmakers. "Making games allows me to create a world that players can explore themselves, and that's a concept that I really like. I can build worlds and systems and then see how people react as they play.

"That, and it's hard to make films," he added with a laugh. "You need to hire actors and have cameras—it's an expensive process!"

CREATING ATMOSPHERE THROUGH SHADOW

Throughout cinematic history, filmmakers have devised clever solutions when faced with a lack of funds. For example, early German expressionist filmmakers had to be inventive in set design because they didn't have the budgets of big Hollywood productions.

In 1920s films such as *The Cabinet of Dr. Caligari*, *Metropolis*, and *Nosferatu*, which heavily influenced *NaissanceE*, one popular fix was to simply paint white onto the sets to indicate lights. This heightened the impact on the audience by emphasizing the alien, hostile milieu that the directors wanted viewers to experience. *NaissanceE* follows in this tradition with its stark black-and-white aesthetic and sharp, angular environments.

"I could have made a more colorful game that played exactly the same way," Sedeño said. "But black and white is more hostile and cold—and unusual. There are not a lot of games out there that don't use color. I took advantage of that to make players feel like they are in a different world."

NaissanceE exists in a very different social environment from the gritty 1920s expressionist cinema that informs it, so you might ask Sedeño why he created a game like this.

"I like watching players react to what's going on and how they go about interpreting the various elements of the game," he said. "It's one of the best things about

Opposite and following page: In-game art from NaissanceE (Mavros Sedeño)

game design! I get to work on every aspect of creation, and then I can see the game through others' eyes in Let's Plays. This is why I want to keep working in games."

Sedeño also favors the surrealist movement, which is characterized by a rejection of established boundaries and social and political rules. We see this play out in his willingness to undermine the expectations players have formed through conventional games. Just as Salvador Dalí's paintings defy such concepts as physics and natural form, so too does *NaissanceE* reject "the way games are made." A deliberately obtuse narrative, the absence of color, a world filled with sharp and cold angles—at every stage, *NaissanceE* provides an experience that turns the expectation of how a game *should* be made on its head.

LYING IN WAIT

Sedeño he enjoys knowing that each person will interpret the *NaissanceE* experience differently—just as everyone interprets a great work of art through an individual perspective.

"My goal was to let players use their own imagination to build their own stories, or at least their own interpretation of the game," Sedeño said. "*NaissanceE*'s success as a game depends on the imagination of the players."

You'll know from the moment you start *NaissanceE* that you're fleeing something. The phrase "Lucy is lost" floats up on the screen at the beginning, and the opening chase sequence has the player running away from an abstract enemy. You need to figure out what's going on in this vast, unknown environment where Sedeño has crafted a pervasive sense of unease.

The world of *NaissanceE* feels sterile and artificial, and the game's puzzle rooms reflect those themes. At times, for instance, you can see lights, but you can't identify their source. As another example, one room transitions between being pitch-black and saturated with white, and in both these states, the exit is impossible to see. You can only escape during the transition.

With dialogue and other traditional narrative tools in short supply, *NaissanceE* requires you to explore in order to advance in the game. Each room teaches you through a simple feedback loop: solve a puzzle and move on to the next challenge. But the stark visual style creates an atmosphere of hostility that keeps you on your toes. The voiceless in-game avatar is designed to be a projection of your will, and while *NaissanceE* rarely presents the kind of immediate and visible danger that you'd face in a more traditional game, Sedeño certainly makes you feel that danger lies in wait at every step of your adventure.

THE NEXT ADVENTURE

Independent game developers are no different from independent artists in other

fields, and at times, working on the next idea is a challenge. *NaissanceE* certainly has a fan base, but the game hasn't been a mainstream hit. While Sedeño has plenty of ideas for future games, it might be awhile before he's in a position to develop them.

"I have a lot of projects planned, and some of these are very experimental. But I also have some more-conventional games in mind, such as a strategy game or racing game," Sedeño said. "What I'll be able to do next depends on a few things. *NaissanceE* didn't sell a lot, so I don't have enough money to produce the next game right now, but I will find a solution to make new games. *NaissanceE* was just the start!"

In-game art from NaissanceE (Mavros Sedeño)

CREATIVITY UNDER CONSTRAINT

A limited budget doesn't necessarily hold independent developers back in terms of creative ambition. Just ask Peter Budziszewski and Tamara Schembri, the duo behind Australia's ToyBox Labs and creators of abstract indie art game *flowmo*. Budziszewski has experience with the largest of studios—he worked with Team Bondi on *L.A. Noire* and with rhythm game

In-game art from flowmo (Peter Budziszewski and Tamara Schembri)

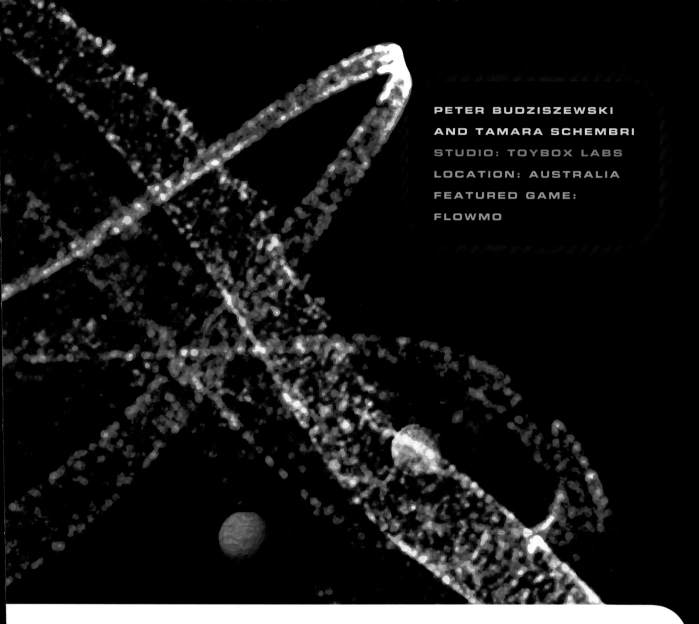

PETER BUDZISZEWSKI
AND TAMARA SCHEMBRI
STUDIO: TOYBOX LABS
LOCATION: AUSTRALIA
FEATURED GAME:
FLOWMO

legend Harmonix—but he doesn't think that working as an indie on a project like *flowmo* has in any way stifled his creativity.

"Take music for instance. Sure, a big orchestra might get better results in an objective sense. But a single instrument, when performed well, can be equally impressive!" he said. "Every great piece of art should have that *wow* effect."

He continued, "When people try to impress you and try and overcome constraints, the act of creation itself becomes a kind of performance. I write code, so when I look at a game, I imagine what's constraining it,

and I can see the code as almost a performance, as something the developer had to overcome. I'm very strongly of the view that having constraints is what will make games interesting for the foreseeable future."

LETTING PLAYERS DISCOVER THEIR OWN MESSAGE

flowmo is an example of Budziszewski's thinking in action. When he and Schembri decided to turn a particle simulator—literally, dots floating on the screen—into a game, they wanted to create something abstract yet full of meaning.

In this game, you manipulate particles at will while an ambient musical soundtrack plays in the background. As you manipulate the particles, the soundtrack will change dynamically to reflect your actions. Your actions then impact how the game plays out, but the effect is subtle: at times, you may not even know you're manipulating the flow of the game. Schembri and Budziszewski want players to apply their own meanings to what they're doing.

"If you've got a message to convey, you're often not sure that your audience is going to get it," Schembri said. "But if you present it in a way that's too obvious, then in a way, you've subverted your own message. It's a balancing act: you need people to figure things out for themselves, yet you need to nudge them in the right direction.

"If you create something complex and interesting enough, people create their own messages in their head, and that's okay too—as long as they don't feel like they're getting nothing from the experience."

Games that are abstract and nonnarrative, either by choice or out of necessity, are open to interpretation, and Budziszewski and Schembri are comfortable with that. "The player should be as much a part of the creation of the meaning as the creator," Schembri said.

But, of course, there's always a risk the audience will just walk away confused. Indies can take that risk because they

Opposite: In-game art from flowmo (Peter Budziszewski and Tamara Schembri)

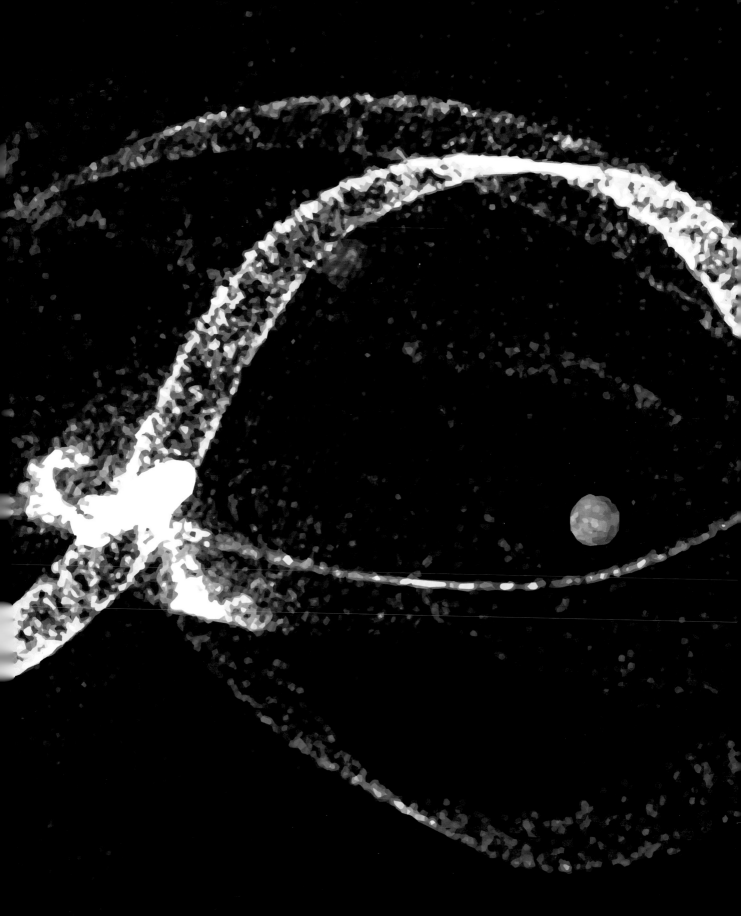

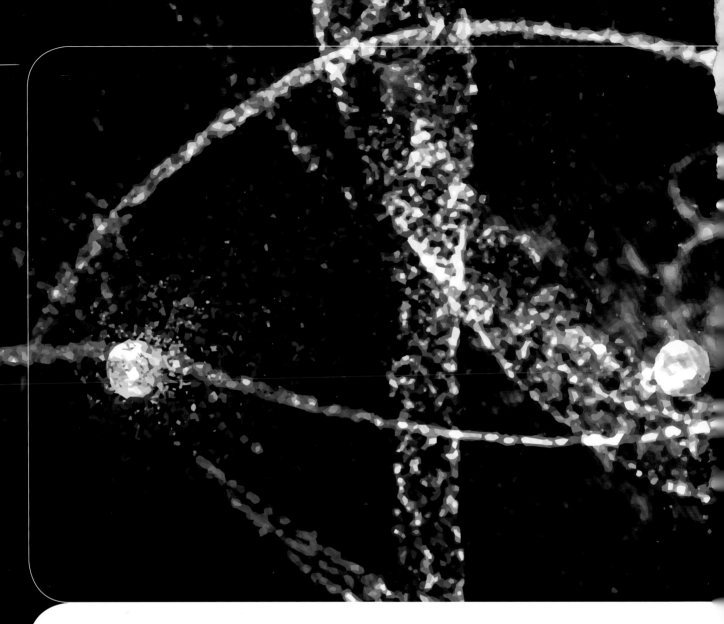

don't need to sell to the mainstream, but developers can still feel anxious about it.

"Up until the last week before we released *flowmo*, we had no idea how it would resonate with the players. Was it going to work? We hoped so," Schembri said.

"Ultimately, I think we came up with something that works for some people but not everyone. That's fine, but it is terrifying. As an indie developer, you have an intuition that the things you're playing with *might* work, but you can't be sure until you actually release it."

In-game art from flowmo (Peter Budziszewski and Tamara Schembri)

EXPERIENCE OVER INTERACTIVITY

ToyBox Labs was Schembri's first job in game development, but Budziszewski's experience goes back further, and it's a clear influence on the team's creative direction. One of Australia's veteran developers, Budziszewski was initially drawn to the industry by the demoscene movement.

"When I was a kid in the '80s, I played games on my Commodore 64," he said. "Back then, games had copy protection, and groups would remove that protection to pirate the game. In order to brag about it, they would put an introduction scene into the game that said, 'This game was cracked by X, Y, or Z.' Over time, people added effects to the screen, such as a bouncing logo, and

eventually, the intros were more technically impressive than the games themselves!

"When I was 10 or 11, I would get pirated games just to see the introduction. I had no interest in playing the game. People started to say, 'Well, what's the point of even having the pirated game? Why don't we just have the stand-alone demo?'

"Those demos were basically pure art. They were noninteractive special effects where people would try to push a machine's capability. I was fascinated by the idea of programming computers to create effects that the designers of the machines had never anticipated."

Budziszewski has always been more interested in providing an experience than in giving players true interactivity. He agrees that interactivity is important—it is the element that differentiates games from film, after all—but that side of game development just doesn't interest him. Other independent developers are also starting to challenge just how interactive the game experience needs to be. With the likes of Dan Pinchbeck's *Dear Esther* and The Fullbright Company's *Gone Home*, indies are experimenting with the idea that simply experiencing a game is as important as controlling its action.

"The thing is, it only takes very limited interactivity to create a very powerful sense of immersion," Budziszewski said. "Something as simple as a character editor allows you to feel like you own that character—even if you then follow a linear plotline." Budziszewski and Schembri will undoubtedly continue to challenge players to find meaning in the experience of abstract game designs.

Opposite: In-game art from flowmo (Peter Budziszewski and Tamara Schembri)

CHEERFUL COLORS AND SIMPLE GAMEPLAY

As the founder and creative director of Australian studio Nnooo, Nic Watt wants to craft Nintendo-quality games on an indie budget. With no desire for gritty realism, he instead guides his small team of developers to build bright, colorful experiences that draw players in.

Promotional art for Spirit Hunters Inc (Nnooo)

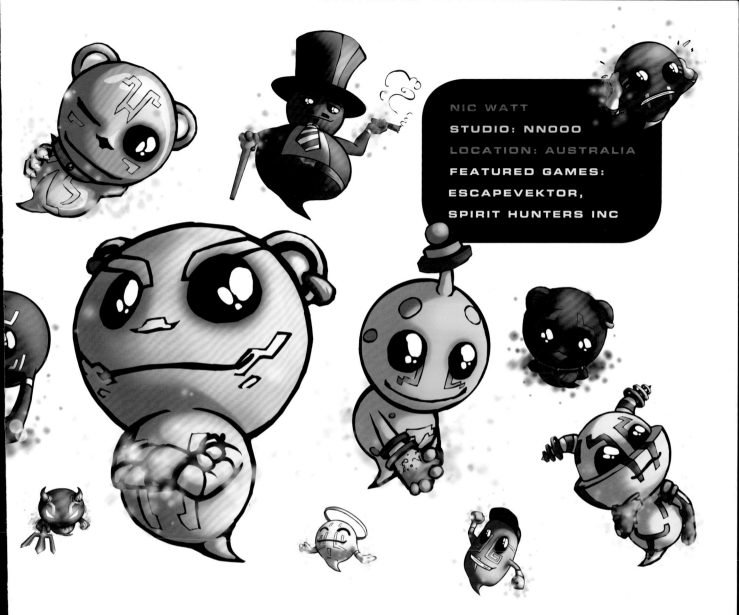

NIC WATT

STUDIO: NNOOO

LOCATION: AUSTRALIA

FEATURED GAMES:
ESCAPEVEKTOR,
SPIRIT HUNTERS INC

Nnooo's first game was *Pop*, a shooting gallery where players pop bubbles to earn points. The studio's next release, *escapeVektor*, is a retro-themed game that plays like a wireframe version of *Pac-Man*, and *Spirit Hunters Inc* takes yet another turn, having players track down and battle a range of cute ghosts. Each game has a different genre, play style, and target audience, but they all emphasize Watt's dedication to simple mechanics and bright, effective presentation.

"Color is important in our games," Watt said when asked about Nnooo's creative direction. "It hasn't always been a conscious decision, but thinking back, I absolutely do want our games to look bright and be fun and cheery."

Watt feels color is a key component of all games because it's vital to our sense of ownership in the real world.

"Anytime a human is in a space, they will try to make it look nicer in some way—there will be splashes of color," Watt said. "Even if it's a simple piece of paper that we stick on the wall, we will try and do something to the space that we live in. I like to think that people are fairly optimistic and are generally trying to make the world a better place."

ENGAGING PLAYERS THROUGH SIMPLICITY

Watt admires Nintendo for creating simple realities in its games and engaging players with innovative, consistent mechanics. That philosophy has had a huge influence on Watt's own development style.

"Nintendo looks at what it wants to achieve and solves the problem in an elegant way that enhances the player's experience—and I like to work that way too," Watt said.

One major example Watt cites for inspiration is the Nintendo DS, which used a touch screen and a stylus to provide players with new methods of interaction and an increased sense of immersion.

"Nintendo produced games like *Nintendogs*, where players feel more connected to their virtual pet because they can physically pet it and play with it. The more you tie people into the familiar, the more it sparks their imagination, and when that happens, the player simply understands what the game is about. With our own games, we've found that the more abstract the game is, the harder it is to sell people on it."

Nintendo has also influenced Watt's philosophy toward world building.

"I've always admired how Nintendo games have a very consistent set of rules, and you never come up against something that conflicts with that set of rules. In *Zelda*, you won't ever come up against a door that you can't open. That happens in plenty of other games, but when it does happen, the world becomes inconsistent."

Solar Rays

Tap and hold on your opponent to hit
them with Solar Rays.

"It frustrates me when developers deliberately force constraints on players. We see this all the time—a design philosophy along the lines of 'We've got this cool ability, but it breaks the game entirely, so let's design the game so that you can only use it in four specific places.' We never see that kind of thing in Nintendo's games."

SIMPLIFYING 3D GAME DEVELOPMENT

Watt's games never show a player avatar; instead, characters speak directly to the screen, which provides a more immersive experience. You also have very little control over movement: instead, the game world moves around you. Watt said this system is a creative solution to technological challenges.

"Player-controlled movement in a 3D space requires a lot of interactive elements. This creates challenges from a programming point of view. When there are just two of us working on the programming side, it's difficult to achieve something that ambitious. Instead, we've tried to take the conservative route and build up experience so we can jump into full 3D work later on."

GAME DESIGNER AS ARCHITECT

Games were always Watt's first love—he has fond memories of his family's ZX Spectrum—but before entering the games industry, Watt was an architect. The two fields have a lot in common: both are highly creative and demand an understanding of complex mathematics. And just like a game, a building crafted with good design principles in mind can inspire emotion. Watt feels his experience in architecture prepared him perfectly for his career in game development.

"By the end of my degree, I had really focused on the 3D side of architecture, and I had started to tailor my portfolio in the hope that I could apply for game jobs. I remember seeing screenshots of *Zelda* on the N64 and thinking, 'My whole training has been about designing digital spaces—I reckon this is the sort of thing I can do.'"

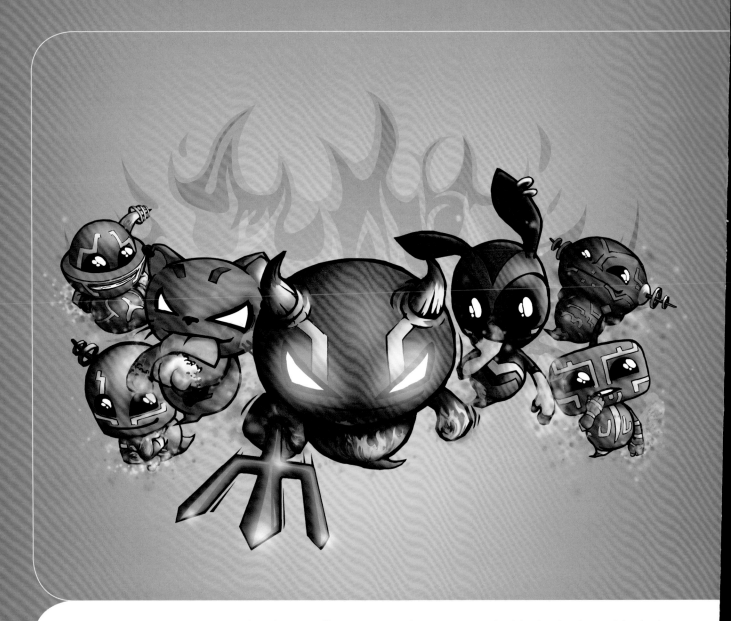

Watt also knows that game developers, like architects, need to be able to resolve the occasional but inevitable conflict between creativity and technology.

"Architects tend to work with a whole bunch of different disciplines. One day you might be working with an interior designer who is mostly concerned with the look and feel of the space. Later you'll be working with the structural and mechanical engineers and focusing on how a building stands up."

Watt continued, "When I came into game development, it was similar. Programming is very math and logic based, and programmers

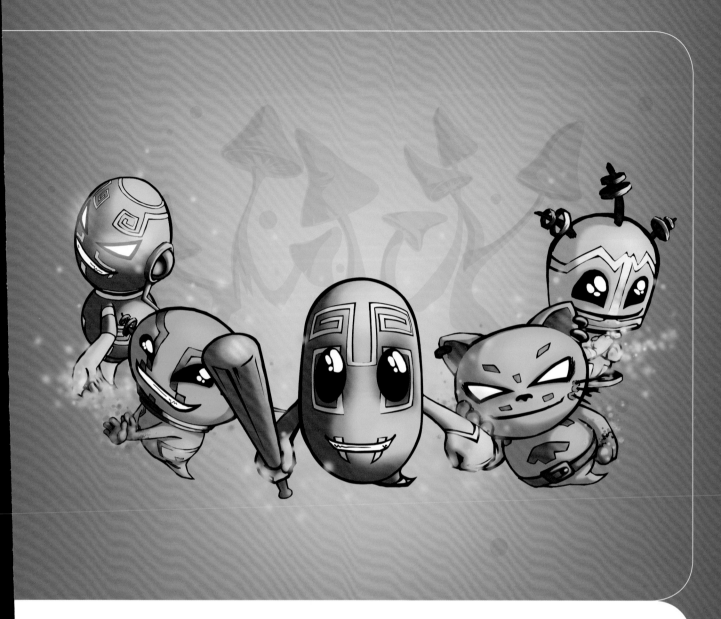

think in a different way than the artists and creative designers do. Having to work with both sides of things can be an interesting balancing act."

Ultimately, striking this balance is Watt's biggest challenge—and overcoming that challenge is the biggest source of his success. Watt's games combine a cheery aesthetic with simple, effective gameplay to offer experiences every bit as compelling as games developed with much larger budgets.

Promotional art for Spirit Hunters Inc (Nnooo)

CULTURE
AND HISTORY

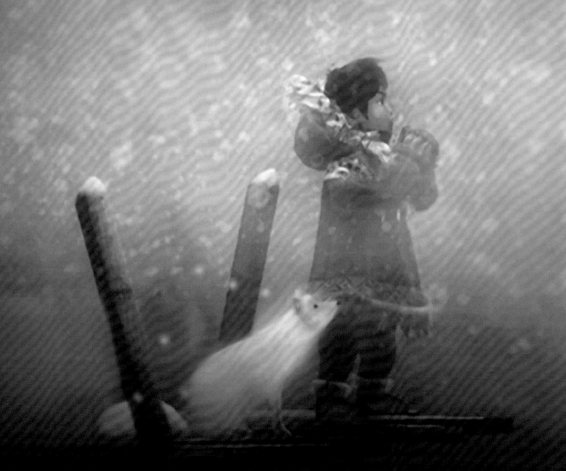

REPRESENTING NATIVE CULTURES

Throughout history, people have used art to pass their wisdom on to younger generations and explain their culture to those who live outside it. Films like *Rabbit-Proof Fence* (2002) and *Atanarjuat: The Fast Runner* (2001)— about the Australian aboriginal people and the Inuit of Canada, respectively—have brought the philosophies and experiences of indigenous cultures to a wider audience,

Previous page: In-game art from Never Alone (E-Line Media)

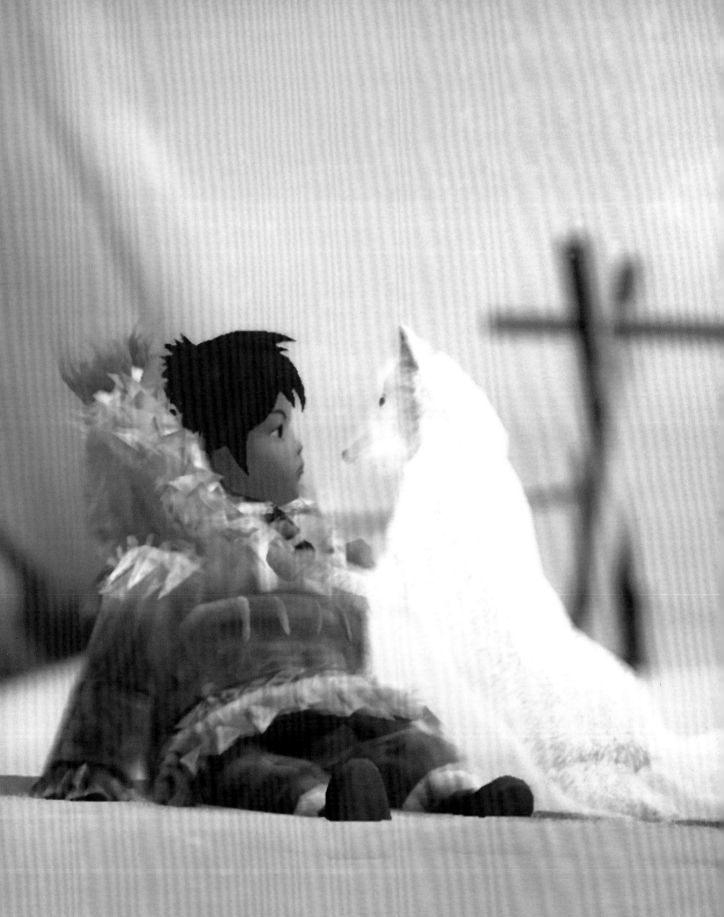

about answering math questions, or perhaps working with a typing-tutor game. These are attempts at *gamification*, the application of game-like interactivity in nongame contexts to engage users in solving problems.

The problem with this style of educational game is that it gives more consideration to being educational rather than to entertaining. Gershenfeld said, "We were very careful to make sure that *Never Alone* could compete in the indie game space, rather than behave as an educational game, because otherwise it would fall into what we term a *valley of insufficiency*. It would not have been well tuned for effective integration into the classroom, but it also it would not be fun enough to get people to choose to play it in their discretionary time."

Concept art from Never Alone (E-Line Media)

Gershenfeld believes that games need to be carefully attuned to their context of use. Furthermore, he believes in the power of popular media and commercial games to inspire life and career choices.

"I can't tell you how many people I know personally who have had their career trajectory inspired by a piece of popular media," he said. "My brother is a well-known MIT physicist, and he's devoted much of his career to trying to create the replicator from *Star Trek*. That series is what got him interested in the science of making things, and then he started to learn more about it, because he was more interested in it, and he wound up becoming a scientist. I was just meeting with a cousin who is a death row attorney, and I asked what inspired her to take up that kind of work, and she

talked about a short story that she read and remembers to this day that was a science fiction metaphor for death row.

"If you want to educate people, whether it's through a novel or a movie or game, you still need to provide great entertainment, but if you fire up the imagination in just the right way, you can end up having an enormous educational impact."

Never Alone is fun to play, but the gameplay is also carefully interleaved with video documentary segments. Featuring interviews with the Alaska Native population, as well as gorgeous shots of the Alaskan wilderness, these videos explain the game's connection to Alaska Native history and culture. The game's mechanics then reflect the themes explored in the videos.

In-game art from Never Alone (E-Line Media)

For example, Alaska Natives believe that the spirits have power to aid them, and in *Never Alone*, spirit guides create platforms to help you progress. When you both play the game and watch the documentaries, you're learning about the Alaska Natives and their culture from a source much more engaging than a textbook.

A CAREFULLY CONSIDERED PAIRING

In *Never Alone*, players have to figure out how the girl and fox can work together to overcome a host of challenges, and the setting adds a persistent third character to the mix, making the game unique and interesting.

"The Alaska Natives need to learn how to read the water and the wind and clouds

in order to make sure they're able to survive in the environment. It's a very harsh environment, and we worked hard to reflect that in the game," Fredeen said. "And, while we wanted it to be a game that everyone could play, we also wanted there to be challenge for the more dedicated players. Providing challenge generally means that characters need to be able to 'die' if the player makes a mistake, so we sat down and had a long discussion about how death relates to the Alaska Native people's cultures and how we could reflect that both in the gameplay and in the narrative."

That discussion, in part, led the team to settle on the white fox as the girl's animal companion. The indigenous people of Alaska have an almost spiritual relationship with a wide range of animals that provide companionship and help with survival. When *Never Alone* was in early development, the team designed art and animations for a wolf companion but later decided a fox was a better choice. Gershenfeld and Fredeen felt that perhaps an audience would react with more sympathy to a fox than to a wolf, given the reputation that wolves have in most of the world.

"The other reason we changed the animal companion is that from the start, we wanted to achieve true interdependency between the human and the animal. We wanted equal but different characters to be working together," Gershenfeld added. "The wolf stood for a good set of metaphors that could have worked within the theme of the game, but the game design team felt that his presence would have upset the balance between animal and girl. The fox seemed to work better for that reason."

The fox also has significance in many other cultures. There are Japanese and Chinese myths, for example, that feature a white fox. By featuring elements that cross cultural lines, video games have the potential to bring people together, allowing them to experience what they hold in common. Gershenfeld hopes *Never Alone* can inspire other indigenous peoples to start representing their own cultures through games.

Opposite: In-game art from Never Alone (E-Line Media)

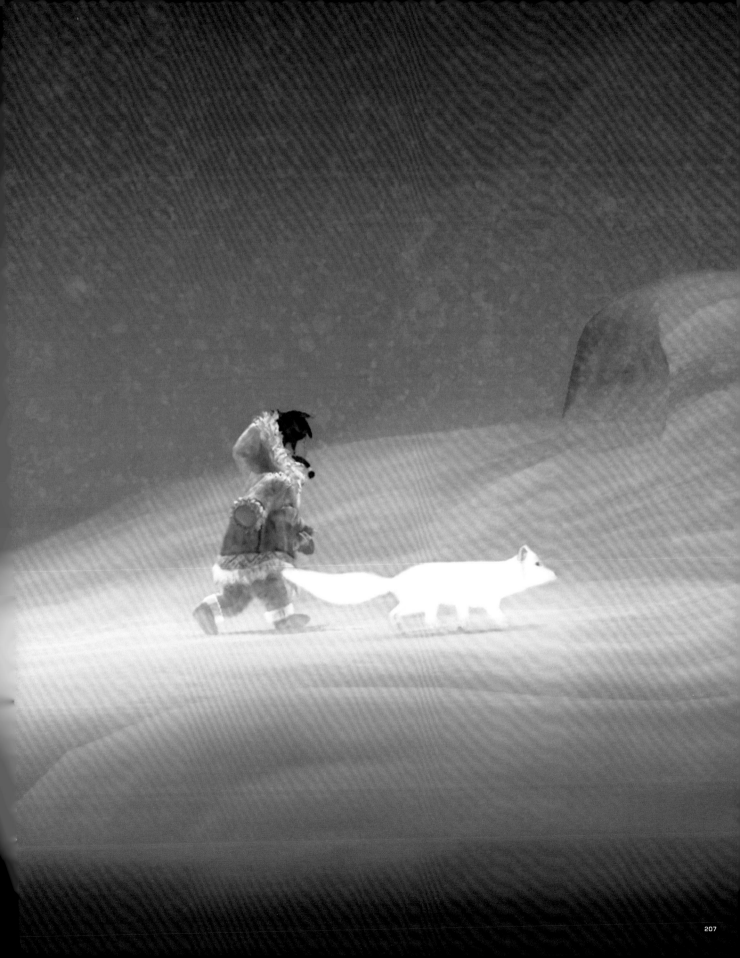

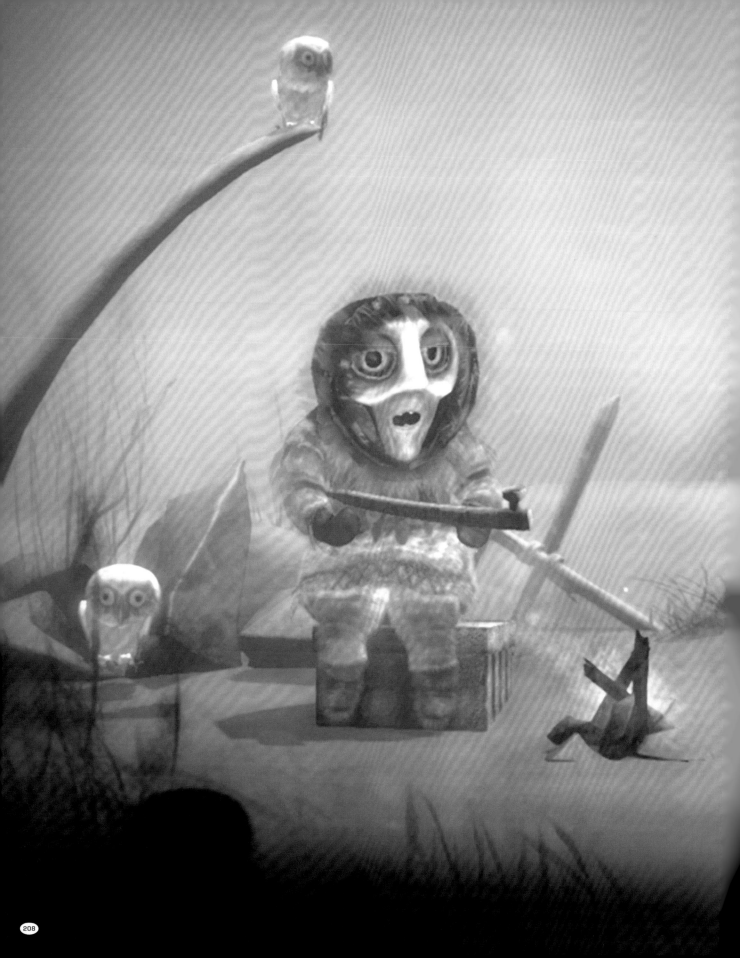

"It was fascinating that when we were first showing *Never Alone* to the media, a number of Japanese journalists came up to us and asked us about the meaning of the fox," Gershenfeld said. "We realized that this wasn't the only part of the history and mythology in Alaska Native culture that has parallels with other cultures from around the world.

"If our idea of World Games does take off as a movement, it's going to be interesting to see how games reflect the similarities and differences of these indigenous cultures. Because ultimately what is deeply human applies across all cultures in the world, and I see games as a way to reflect on and celebrate both our uniqueness and our similarities."

In-game art from Never Alone (E-Line Media)

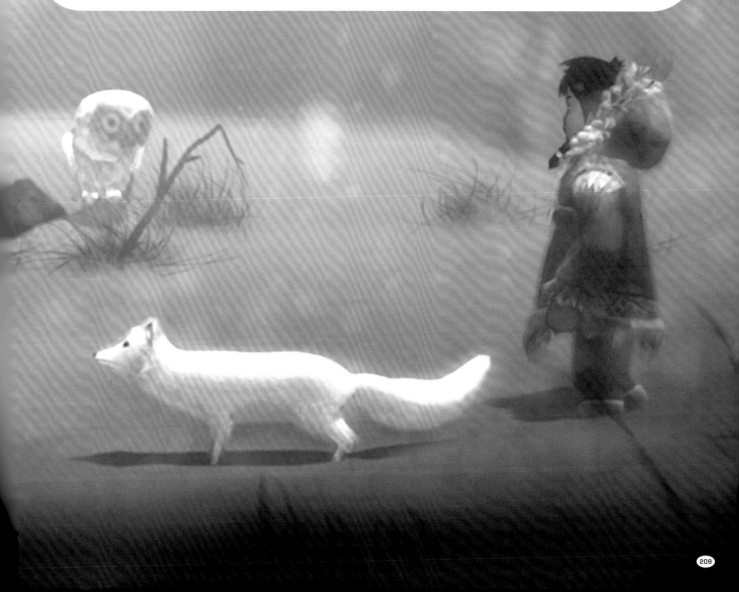

REMIXING HISTORY

Historical fiction can teach you a great deal. In *Samurai Warriors* and *Dynasty Warriors*, Koei Tecmo aims not only to create a visceral, thrilling experience through historical stories but also inspire players to learn more about the events they just played through.

"Just like the saying 'Truth is stranger than fiction,' there are very fascinating characters and episodes in history," said Akihiro

In-game art from Bladestorm: Nightmare (Koei Tecmo Games)

AKIHIRO SUZUKI AND HISASHI KOINUMA
STUDIO: KOEI TECMO GAMES
LOCATION: JAPAN
FEATURED GAMES:
BLADESTORM: NIGHTMARE,
DYNASTY WARRIORS,
SAMURAI WARRIORS

Suzuki, the director and producer of the *Dynasty Warriors* franchise, a historical fiction game set in ancient China. "The key in history games is being able to experience these fascinating episodes and play the roles of various characters."

While Koei Tecmo has produced more-straightforward historical simulations, the *Warriors* series is filled with embellishments: for example, the hero wears outrageous

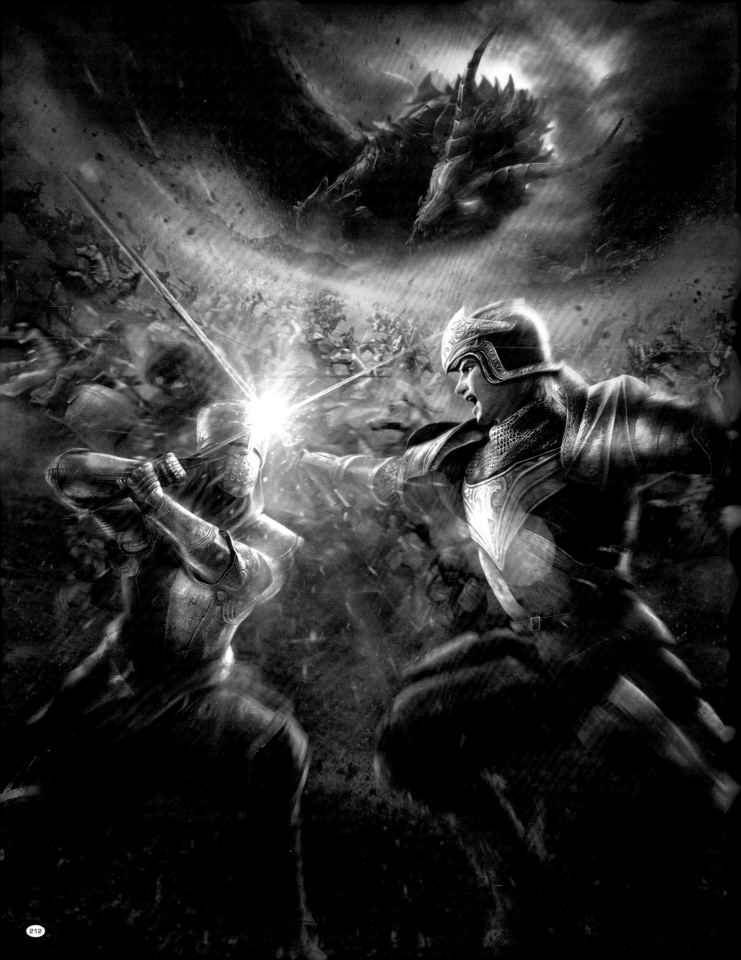

costumes, wields impossible weapons, and cuts through thousands of enemies without slowing down at all. But, while the *Warriors* series turns the historical world into a fantasy world, each game also aims to remain tonally and symbolically true to its source material.

A self-professed history buff, Suzuki initially came to work for Koei Tecmo because he'd played Koei games as a child (Koei was then a separate company from Tecmo). "When I was in high school, I played the *Romance of the Three Kingdoms* series and was greatly impacted by how fun and interesting it was," he said. Now, as one of the most senior creative talents in the company, Suzuki is making the kinds of games that initially inspired him.

Thanks to Suzuki's great respect for history, even as the characters and action become more outlandish with each new *Warriors* game, the core of historical truth remains mostly intact. "We are careful not to deviate from history too much," Suzuki said. "Rather than change major historical events, such as deaths of individuals or victories and defeats in battle, we make scenarios more dramatic by focusing on how the emotions and thoughts of the characters are portrayed, allowing players to make their own individual interpretations.

"Regarding the costumes and weapons— of course they're not realistic!" he added. "If we were to create completely authentic replicas, the game itself would be too modest and lack variety, so instead our designs are inspired by the trends of that time period. We want a large, diverse collection of costumes and weapons, so even though we stick to realistic base features, we play around with parts that can be open to arrangement."

Indeed, in *Dynasty Warriors*, *Samurai Warriors*, and other Koei Tecmo games, even the most outlandish weapons and environment designs are rooted in historical authenticity.

While developing *Bladestorm*, a game set during the Hundred Years' War in medieval Europe, Suzuki went the extra mile to

Opposite: Promotional art for Bladestorm: Nightmare (Koei Tecmo Games)
Following page: In-game art from Bladestorm: Nightmare (Koei Tecmo Games)

ensure the game would be authentic despite featuring fantasy elements.

"With *Bladestorm*, similar to how we created our other historical games, we collected and referred to many different literary and reference materials," Suzuki said. "And since European history is something that we were not familiar with, the game director, art director, and I visited England and France to research firsthand the various historical sites and castles. We returned with many reference materials that were only available locally."

VICTORS WRITE THE HISTORY BOOKS

In war, the winner claims the status of hero, while the loser becomes the villain. Historians grapple with this issue constantly when trying to determine the truth of events.

The Three Kingdoms period, in which *Dynasty Warriors* is set, occurred between 220 and 280 CE. Historians are still trying to piece together what actually happened in China during this time, and because there is so much uncertainty, eras like this can be rich sources of inspiration for historical fiction.

With *Dynasty Warriors*, it's not even certain that every character in the main source material on the period—*Romance of the Three Kingdoms*, a historical novel attributed to Luo Guanzhong and probably written in the 15th century—ever existed! *Romance of the Three Kingdoms* claims one Chinese warlord, Cao Cao, was a villain and tyrant, and it portrays two others, Liu Bei and Sun Quan, as heroes for defeating Cao Cao. Historians generally agree, however, that the truth is more complex.

Likewise, historians debate the events surrounding the Sengoku period (1467–1603), in which *Samurai Warriors* is set. In this period, the infamous warlord Nobunaga Oda was ultimately betrayed to his death by one of his most valuable generals. Popular fiction about the period typically paints Oda as a ruthless genius, if not a tyrant. But in a time of political strife, perhaps Oda was one of the few who could bring stability and prosperity to Japan.

114 CHAIN

Xun Yu

This territory now belongs to me.

Advance

In light of the persistent uncertainty over historical facts, Suzuki and his team at Koei Tecmo felt it would be disingenuous and limiting to cast significant personalities such as Oda and Cao Cao in the role of "absolute villain." After all, these leaders had their own visions for how they wanted the world to be, and if they had come out on top, they would have been the heroes of those same history books. With this in mind, Koei Tecmo's games have always worked hard to present a balanced viewpoint, inviting you to understand the characters' rationales for their actions.

"With historical figures, the line between 'hero' and 'villain' is also based on individual interpretations, so there are cases where

a person's interpretation of an individual's actions is not based on an objective truth," Suzuki said. "In that sense, we make sure not to draw clear lines of good and bad for players, which allows us to use many scenarios that don't rely on a bias toward good or evil.

"We also do this out of consideration for the descendants of these historical figures," he added, showing again that for all the fast action and crazy designs in the *Warriors* games, Koei Tecmo has the utmost respect for the reality on which it bases its games. This respect carries over to setting and characterization, as well.

Above: In-game art from Dynasty Warriors (Koei Tecmo Games)
Following page: Promotional art for Samurai Warriors (Koei Tecmo Games)

LITERAL AND SYMBOLIC DESIGNS

When Hisashi Koinuma, a Koei Tecmo veteran who has produced games in the *Kessen* and *Samurai Warriors* franchises, and his team bring real Japanese castles into a game, they carefully re-create the likenesses of the originals, from the woodwork to the stone patterns of the foundations.

But real Japanese castles contain design elements that wouldn't be fun in hack-and-slash games like *Samurai Warriors*.

For example, the walls have small slits for archers and gunmen to fire from safely. In the games, players would be annoyed if they were fired on with no way to fight back against the archers inside, so castles in *Samurai Warriors* don't have these arrow slits. The building layouts, however, including staircases that loop to a single command room at the top, do carry over from historical castles. The game's castles even lack homey decoration because, unlike European castles, Japanese castles were used purely for military purposes.

Above: In-game art from Samurai Warriors (Koei Tecmo Games)
Opposite: Photograph by Matt Sainsbury

Koinuma sought out opportunities to distinguish the *Samurai Warrior* series from other action games, anime, or manga set in the Sengoku period by using authentic historical events that are also really fun. For example, the fourth battle of Kawanakajima (1561) included an especially famous fight between powerful warlords, Kenshin Uesugi and Shingen Takeda, and you'll find it in any *Samurai Warriors* game.

In the original battle, Uesugi took Takeda's forces by surprise, and as Uesugi burst into Takeda's command post, Takeda was wielding only his war fan. He fended off three attacks from Uesugi despite being essentially unarmed before Takeda's retainer speared Uesugi's horse, forcing the attacker to flee.

As Koinuma said, "In *Samurai Warriors*, just having a standard sword and spear wouldn't make for a fun game, so we needed to come up with a greater range of weapons to make the game more interesting." Indeed, this story provided an opportunity to broaden the range of weapons—Takeda wields a war fan in the game—without completely fabricating what happened.

Uesugi's in-game representation also wields a fanciful weapon: a sword with seven prongs. According to the story of that one-on-one battle, Uesugi's three strikes had such force behind them that even though Takeda deflected the attacks, there were seven notches left on the war fan. Uesugi's blade in the games has seven prongs to correspond to the story—and because it looks cool.

To bring more variety to the *Samurai Warriors* cast, however, some historical figures were changed beyond just giving them a fun weapon.

REFLECTING MANY PERSPECTIVES

In Sengoku-era Japan, women were not samurai. Women did commonly participate in the logistics of warfare—for instance, they maintained weapons, and after firearms were introduced to Japan, they made bullets—but they were generally noncombatants. Those rare women who

did take up arms became famous, much like Joan of Arc.

According to Koinuma, Koei Tecmo wanted a better balance of male and female characters in the *Samurai Warriors* series to convey a wider range of motivations, emotions, and viewpoints. "I look at the personalities of the people of the Sengoku period, and they all have their own beliefs and ideas for the future, and that's something we wanted to create in the game," Koinuma said. "We wanted to portray all the different points of view and the different ways of thinking, and reflect that in the storyline itself."

Writings show that the real Kaihime (Lady Kai) did take up arms to defend her people. And Ginchiyo Tachibana may not have fought in real battles, but she was the head of the Tachibana clan for six years in the absence of any men and so ran the household. The development team easily reimagined her as a warrior. Another female character in the game, Kunoichi, doesn't represent a real person. Instead, she's a composite of a group of real female warriors who were present in many Sengoku conflicts. (*Kunoichi* is the term for a female ninja.)

"It's difficult in a sense, but it's also a lot of fun to do," Koinuma says of tweaking historical facts.

Koei Tecmo's historical fiction games indulge in the hypothetical, imagining how one heroic act *could* have impacted events. For example, what if Joan of Arc hadn't been burned as a heretic during the Hundred Years' War? *Bladestorm* allows you to explore that alternate timeline by rescuing her from captivity—and changing the course of history.

"When we're building our battles, we think to ourselves, 'If this were to happen, what would take place next?'" Koinuma said. "We do this so we can include new characters in the battle and also allow characters who were historically on the losing end to change history and win. But we need to add them in a way that won't change the context and importance of the battle. It's great fun!"

CHILDHOOD INFLUENCES

TWISTED FAIRY TALES

American McGee is best known for his reimagining of *Alice in Wonderland*, and his style, often likened to something out of *Grimms' Fairy Tales*, is informed by some dark moments in his life.

Problems at home forced McGee to drop out of high school despite his academic ability, and he was working in what

Previous page: Promotional art for Crazy Fairies (Spicy Horse)
Above: Concept art from Alice: Madness Returns (Ken Wong/Electronic Arts Inc.)

AMERICAN MCGEE
STUDIO: SPICY HORSE
LOCATION: CHINA
FEATURED GAMES:
AKANEIRO: DEMON HUNTERS,
ALICE: MADNESS RETURNS,
AMERICAN MCGEE'S ALICE

felt like a dead-end job as a car mechanic before he got his big break in the video game industry. Sheer luck and good timing changed everything when his next-door neighbor, programming legend John Carmack, offered him a job at ID Software. There, McGee cut his teeth on games such as *Doom 2*.

"Going from an existence that was not very satisfying or happy to one in which I was surrounded by rock stars of the games industry, and being offered an opportunity to learn and contribute to their work, was a pretty radical life change and a life-changing experience for me," McGee said.

"ID Software had a unique culture within the business. It was very much like a frat club or boys' locker room. We were making very violent games at that time, and it was loud, with people screaming and yelling at one another and playing death matches all day. But at the same time, to have proximity to and influence from people like John Carmack, Michael Abrash, and Sandy Petersen—that was inspiring."

When McGee left ID Software, he joined EA, where he was largely given free rein to create whatever game he liked. That turned out to be *American McGee's Alice*, which would define his career. For such a significant game, *Alice* came from a remarkably ordinary lightbulb moment.

"EA asked me to come up with a new game concept and didn't specify any boundaries," McGee said. "One day, as I was driving along the highway in California, a song popped on, and one of the words in it was *wonder*. The combination of that word plus a lot of the other things that were going on in my life at the time made me realize that I wanted to do a really dark and emotional take on Alice from *Alice in Wonderland*."

McGee's reimagining is a sequel to Lewis Carroll's novel. His story paints Alice's return to Wonderland as her own psychological defense against facing the real-life horror of her parents' death. The dark, twisted world of *Alice* reflects how that experience has scarred Alice, who in the real world is confined to an asylum. In Wonderland, Alice's fear manifests itself as a clashing expressionist landscape filled with sharp angles, and an oppressive ambiance mirrors the claustrophobia Alice experiences in her asylum room. Alice's anger at losing her parents also causes her to have incredibly violent urges. Retreating to Wonderland lets her come to terms with her loss, but the journey is unpleasant.

DEFER TO YOUR CHARACTERS

The psychological horror in *Alice* and its sequel, *Alice: Madness Returns*, is so terrifying in part because the games take place *inside* Alice's head. Everything in the game environment is an extension of that

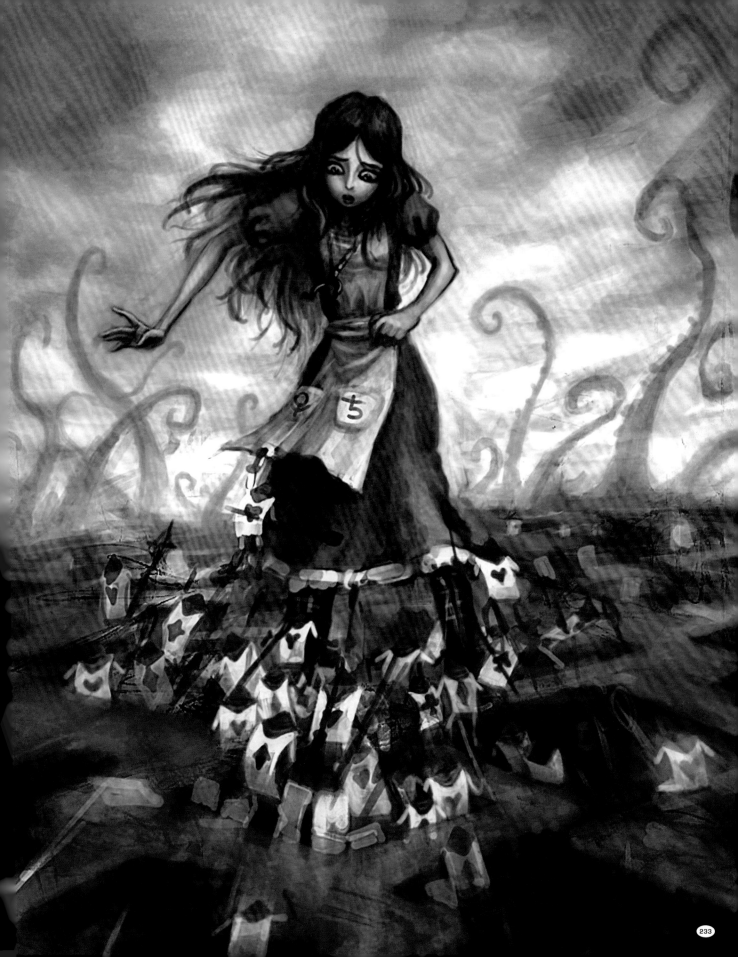

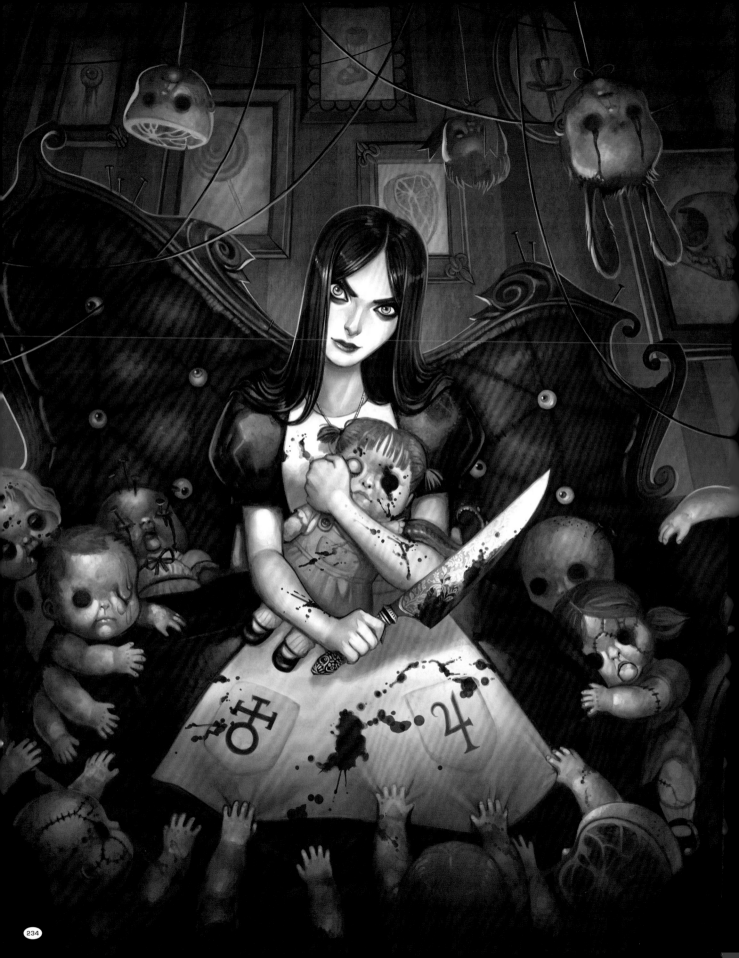

character, which means the franchise's commercial and critical success depends entirely on how deeply and consistently she is imagined.

"During development, if there was any disagreement on how something should work within the game, I would try to remind the team that it had to be about Alice," McGee said. "We needed to pay attention to what she might be saying or wearing, or how she might move through the world."

That focus makes the two *Alice* games highly character driven. They've generated some controversy, but for fans, the design clicked as few games have before or since. Go to any gaming convention, even years after the last *Alice* game was released, and you'll see people dressed in Alice's trademark blue dress, splattered with blood. This is the Alice of McGee's vision.

McGee also ran a successful crowdfunding campaign to produce a series of animated short films starring his vision of Alice, proving that Alice is valued as a character in her own right. A live-action

film adaptation of the story also became a possibility when McGee acquired the rights to the character and world from EA. *Alice*, a game that was always more about the narrative and character than the game itself, has become a cross-media franchise.

GAME DEVELOPMENT AS A SCIENCE

McGee has been a game developer for over 20 years, but in truth, he isn't that interested in *playing* games.

"Games have to be *really* special to pull me in," he said. "Even then, I'll often come away from a game feeling depressed about the time I invested when I compare it to real life—for instance, having a dinner party, learning to cook something new, learning to play an instrument, or building something with my hands."

McGee has a passion for science and discovery, an enthusiasm central to game design. Developing games is demanding—both personally and creatively—but he is inspired by the marriage required between technical skill and creativity and sees his

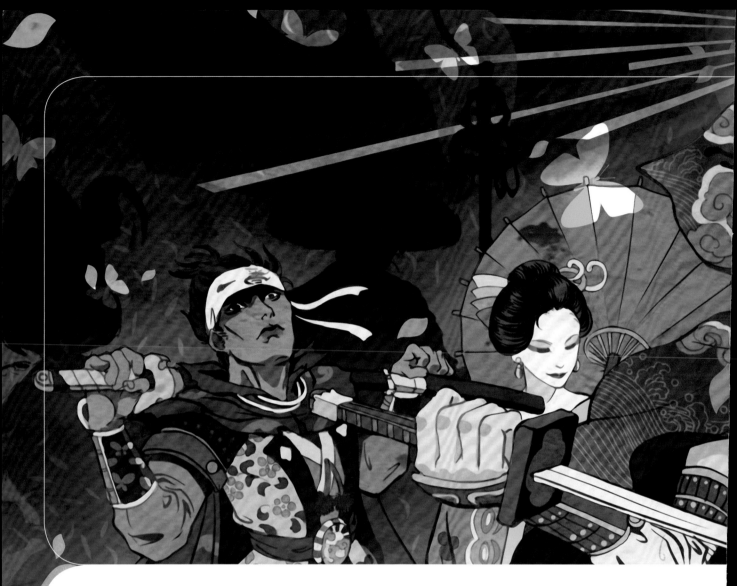

work as an opportunity to explore new ways to do things.

"The expression games afford us, the technology we get to play with, the stories that we get to tell, and the worlds that we get to build—those keep me engaged," he said. "But if I were to have an early retirement from games, I think (and I do think about this often!) that I would go into a more physical medium. Perhaps a combination of computers and robotics, or computers and electric vehicles. Either way, something where there's an intersection between the physical and computers—I am very interested in that space."

KNOWING WHAT PLAYERS WANT

Of course, not all of McGee's games are so invested in a single character or focused on story. In 2007, McGee cofounded the

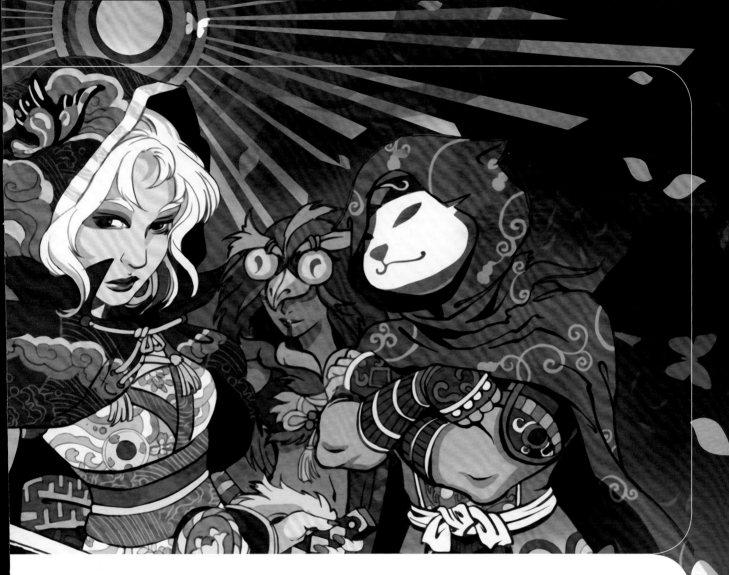

Shanghai-based development studio Spicy Horse, which produces smaller games, designed for mobile devices.

"With mobile games, the story isn't nearly as high a priority as it was with the *Alice* games," McGee said. "*The Gate*, for instance, doesn't have a protagonist. It's just you, as the player, and the demons that you're fighting against. Our goal needs to be different because the audience is coming to the game for a different reason. When people play mobile games, they're looking for something entertaining to engage them, but perhaps only for short bursts of time. An in-depth narrative might not work so well."

That doesn't mean *The Gate* and other Spicy Horse games are less artistic. All of McGee's games feature strong visual aesthetics and

Above and following page: Promotional art for Akaneiro: Demon Hunters (Spicy Games)

simple, engaging gameplay mechanics. In *Akaneiro: Demon Hunters*, for instance, you descend into dungeons and fight waves of enemies for loot and experience, which in turn allow you to fight tougher enemies. Following a common pattern in game design, Spicy Horse set *Akaneiro* apart by mixing "Little Red Riding Hood" with traditional Japanese art and monsters.

McGee's unique games attract a dedicated fan base, and while he doesn't draw the art for the games himself, his skill as a writer allows him to help the artists he hires create worlds consistent with his vision.

"My artistic ability is pretty lacking," he said. "Writing is my main contribution to my projects in terms of creativity. I do game design, production management, and creative development, but teams of people I work with create the artwork, music, and animation."

STEPPING OUT OF THE SPOTLIGHT

McGee doesn't want to produce only dark fairy tales, but he's so well-known for them that he finds it difficult to break away from the theme. In his work at Spicy Horse, McGee has found that to sell a game that isn't a reworked children's tale, he needs to pull back from using his personal brand and put distance between his association with the project and its marketing.

"I have been trying to back away from advertising my involvement with the games that we've produced, as I want the studio itself to build a reputation for producing unique games," McGee said. "Since 2011, we've released four new games, and while two of them have had some fairy-tale overtones, I didn't advertise them as my creations. The other two have had nothing to do with fairy tales, and they've been successful."

McGee's games have made him a genre auteur, prone to disappoint fans if he doesn't work within that genre. And despite his best efforts, McGee may forever be known primarily as the designer who brought the genuine horror at the heart of fairy tales to video games.

Opposite: Concept art from American McGee's Alice (Ken Wong/Electronic Arts Inc.)

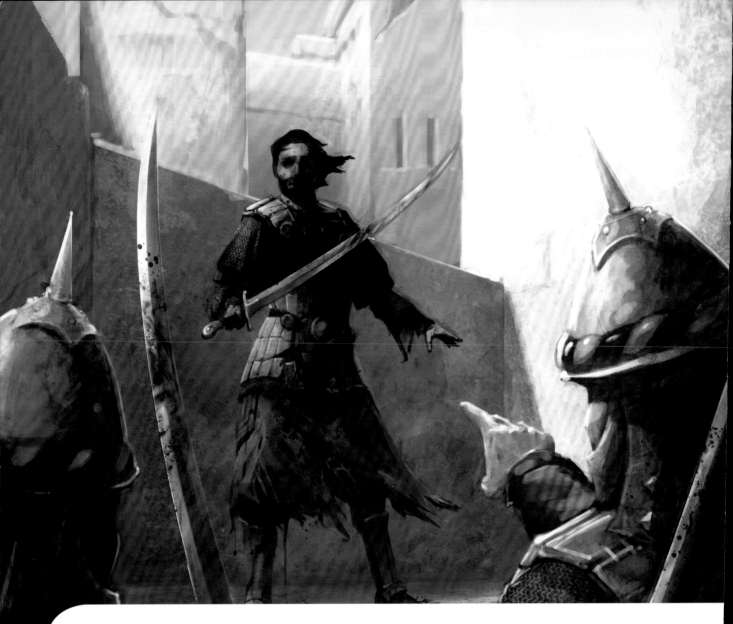

BRINGING CHILDHOOD FANTASIES TO LIFE

Ask any developers when they made their first game, and most will say they started as children. Many industry veterans likely created board games or invented new sports, while new developers are young enough to have created their first game on a computer using simple software like RPG Maker or GameMaker.

In-game art from Gamebook Adventures (Joshua Wright)

NEIL RENNISON

STUDIO: TIN MAN GAMES

LOCATION: AUSTRALIA

FEATURED GAME:

GAMEBOOK ADVENTURES

But Neil Rennison of Tin Man Games got his start by dreaming up detailed worlds for pen-and-paper RPGs, and he's known for his interactive novels, or gamebooks.

Rennison's *Gamebook Adventures* series, available on iOS and Android, owes much to *Fighting Fantasy* and *Choose Your Own Adventure*, two prolific gamebook franchises that became a publishing phenomenon in the 1980s and 1990s. Before video games were mainstream, gamebooks were popular because they were interactive, allowing people to take control of a hero and go on grand adventures. When you start reading a gamebook, it reads exactly like a novel. But you are frequently asked to make a choice

Orlandes, as drawn by 13-year-old Rennison

as you read, and each choice sends you to a different page and a different outcome.

Rennison loved gamebooks as a child, and when he decided to write his own series of these choose-your-own-adventure novels, he turned to his juvenilia as the basis for a more serious work.

"When I was 13 or so, I created a world, complete with maps, for the *Dungeons & Dragons* adventures that I played with friends," Rennison said. "When I started to produce the *Gamebook Adventures* games, I had all these writers working with me, and we needed a world to place these stories within. I thought, 'It's going to take so long to design

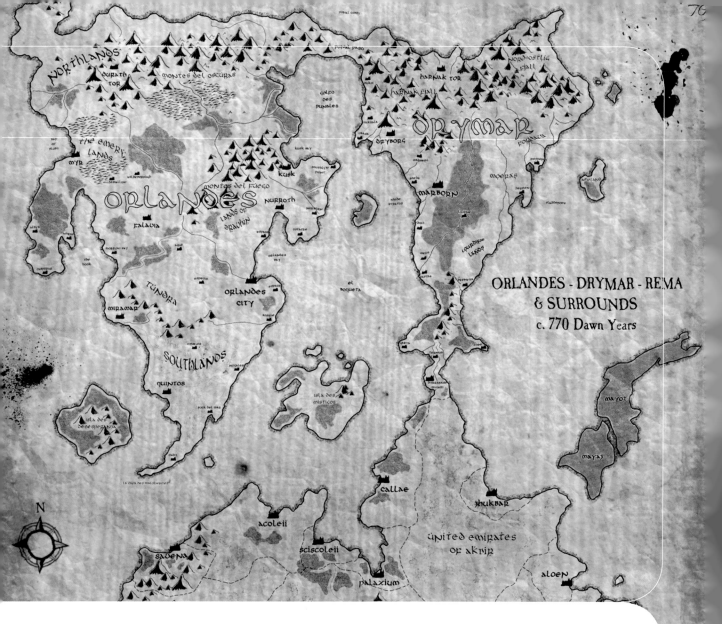

ORLANDES · DRYMAR · REMA
& SURROUNDS
c. 770 Dawn Years

a world from scratch for all these adventures!' But then I realized, 'Why create a new world?' I'd already done it 25 years ago."

Rennison headed to his parents' house, climbed up to the attic, dusted off a box of his old *D&D* adventures, and there it was: the map of his childhood fantasy world. That map of Orlandes would become the basis for all the *Gamebook Adventures* titles. Rennison has since created gamebook video games for other authors (he's even created digital versions of numerous *Fighting Fantasy* titles), but the *Gamebook Adventures* series remains his bread and butter.

Orlandes, as it appears in Gamebook Adventures (Neil Rennison and Dan Maxwell)

AN INTERACTIVE STORY

Rennison began his game development career as a child in 1982. That year saw the release of the first *Fighting Fantasy* gamebook, written by Ian Livingstone and Steve Jackson.

"These guys opened my eyes to what was possible in a narrative," Rennison said. "I had this love affair from the age of 10 onward with both video games and *Choose Your Own Adventure*–style books, and so it seemed logical to have a marriage between the two."

He liked the sense of control such books gave him over the story, and that led him to write the books himself. "I love reading epic fantasy stories, but I sometimes struggle with them, as I've always wanted to manipulate the story myself," he said. "That's why I also got into *Dungeons & Dragons* as a child, playing as the dungeon master and creating the adventure for the other players in the group to experience. I was very rarely a player. I always wanted to be in control."

KNOWING (AND GROWING) A NICHE

Gamebooks have waned in popularity as video games grow richer and provide more-vibrant experiences. But the people who grew up with gamebooks still want to play them, and Rennison has found success by tapping into that niche audience.

"I did an advertising campaign," Rennison said. "Most people who clicked through my ads were male, along the lines of 28–37 years old. That doesn't surprise me at all. A lot of those who played gamebooks as kids have a lot of nostalgia for them. I provide them a means to tap into their childhood. It's important that they, as our main audience, are the ones we satisfy first and foremost."

Rennison has been able to appeal to this core demographic while also introducing younger players to the traditional gamebook genre.

"Young gamers often say to us, 'This is amazing! Did you invent it?' A lot of

Previous pages and opposite: In-game art from Gamebook Adventures (Joshua Wright)

youngsters never had gamebooks and didn't know they existed. All they've known is *Warcraft* and the latest RPG releases," Rennison said.

Other developers have attempted to turn gamebook narratives into full-fledged RPGs or add action elements to better appeal to a younger generation. But these attempts at updating the form have lost sight of the key feature that most gamebook players want: an uncomplicated focus on a compelling story, without distractions like 3D graphics and complex battle systems.

MAKING HIS OWN LUCK

An element of self-made luck has helped Rennison along the way. While his venture was still new, he exhibited at a trade show for RPG fans, and to promote his games, he displayed some art from *Gamebook Adventures*.

Rennison's display wasn't flashy, but Ian Livingstone, who was in attendance, saw it and sought Rennison out to speak to him.

Not long after that, Rennison had a deal to digitize the classic *Fighting Fantasy* novels and release them on iOS and Android, which was both a big boost to his business and a realization of his childhood dream.

"If I hadn't been there, I might never have bumped into Ian and got the *Fighting Fantasy* license," Rennison said.

But going forward, Rennison admits that he'll need to do more than *Gamebook Adventures*, and the time will come soon to try to reach new audiences with new experiences.

"My business partner and lead Tin Man coder, Ben [Britten Smith], and I have talked about what to do beyond gamebooks. We love them, but ultimately we want to push on, and we've got a few plans," he said. "In the future, we would like to forge a new path in narrative-based adventure gaming. Our grand vision is an adventure game that is still quite text based, something like *Skyrim* with words."

In-game art from Gamebook Adventures (Joshua Wright)

A GAME THAT NEVER ENDS

Malevolence: The Sword of Ahkranox is a game that was almost never made. In fact, if creator Alex Norton hadn't faced personal tragedy, he might never have been inspired to develop it in the first place.

"A few years ago, I fell very ill and was hospitalized," Norton said. "I had to have some surgery, and the

In-game art from Malevolence: The Sword of Ahkranox (Alex Norton)

ALEX NORTON

STUDIO: VISUAL OUTBREAK

LOCATION: AUSTRALIA

FEATURED GAME:

MALEVOLENCE: THE SWORD

OF AHKRANOX

doctor gave me an 87 percent chance of not making it through. As you can imagine, that was pretty terrifying.

"The last thing I remember thinking as I was wheeled into the operating room is that if I didn't make it, there'd be nothing of me left behind. Weirdly enough, it brought back memories of how I hated when the games that I'd played as a child ended."

Many parents read stories to their children at bedtime, but Norton's dad was different; he worked night shifts, so he couldn't read to his child at night. Instead, during the day and on weekends, Norton and his father bonded

while playing classic RPGs, such as *Eye of the Beholder* and *Might & Magic*.

"When we came to a crossroads, my father would ask me which way we should go," Norton said. "It was better than a bedtime story because it was something that we were living and breathing together—a world that we got to be a part of.

"As I got older and we would finish the games, I hated that they would end, because the next one was never quite as good—they started to modernize and lose their luster. So, when I came around after the operation, determined to create something I could leave behind, I thought, 'Why not make one of those games that was such a part of my childhood?' But I'd make one that would go on forever."

A PROCEDURAL RPG

With months of time on his hands as he recovered, Norton threw himself into developing his game. For a college project, he had developed an engine to create infinite procedural worlds, but this was before *Minecraft* and other "never-ending"

games were popular. So at first he wasn't convinced that he could make a successful game.

But as he tinkered with the engine, Norton realized he could indeed use procedural worlds to produce a compelling RPG experience. He took his idea to the crowdfunding platform Kickstarter and discovered there was a lot of interest in the project.

"I brought in a few friends who were good artists, and a composer, and suddenly *Malevolence* became a big deal," Norton said. "The scope of the project exploded, and I realized that this could be something really special. *Malevolence* generated a savage following. They're a niche group of players, but they're massively dedicated to it."

Malevolence's main demographic is the over-30, lifelong gamer who shares Norton's nostalgia for classic RPG mechanics. Just like Norton, these players find the idea of having one essentially endless game immensely appealing.

Concept art from Malevolence: The Sword of Ahkranox (Rachel Birchnoff)

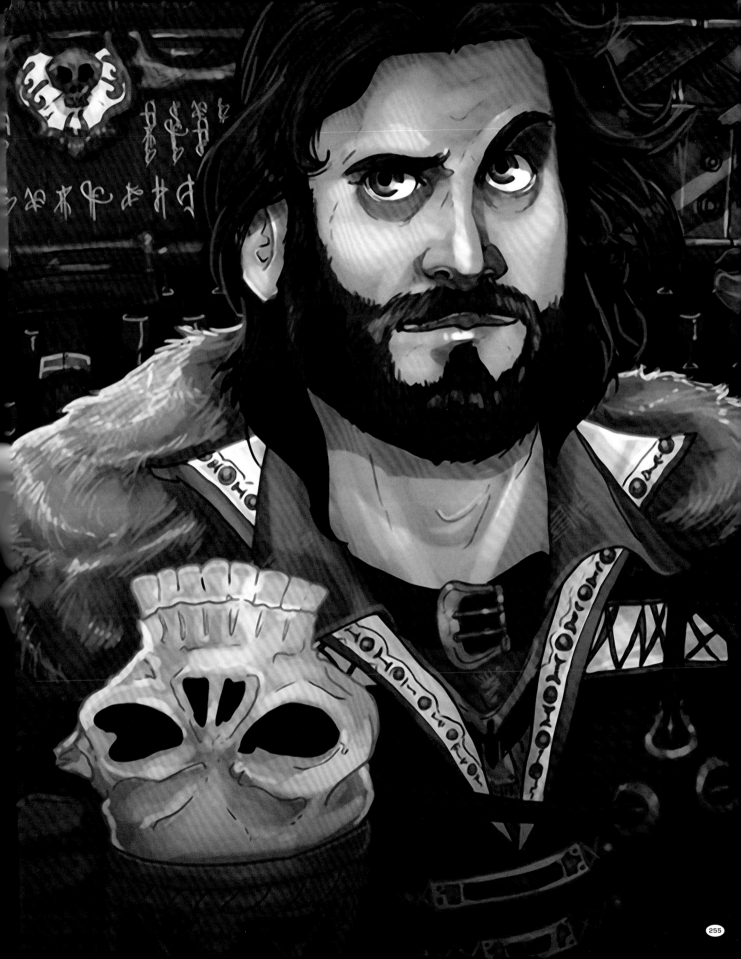

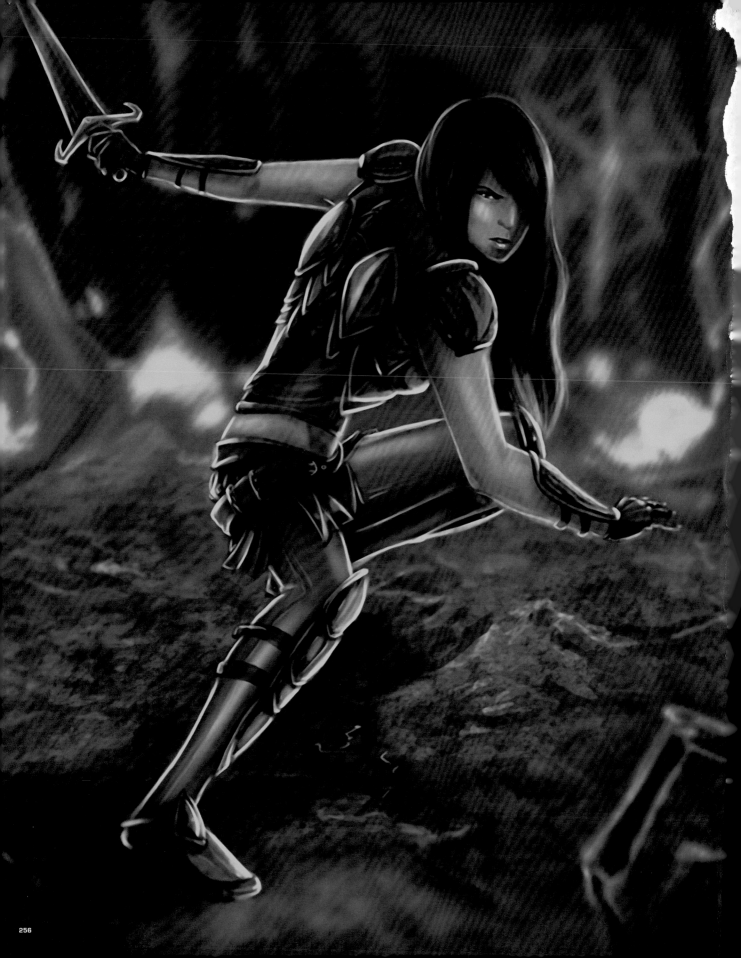

OPEN-ENDED STORYTELLING

Malevolence has a classic RPG structure that gives you the chance to explore trap-filled dungeons and kill hordes of monsters, gaining experience, new weapons, and plenty of loot in the process. Unlike its peers, however, *Malevolence* also borrows from games like *Minecraft* by offering players a procedurally generated world. New environments are randomly generated, and the game world is truly infinite.

But Norton came across a challenge almost immediately. With their entirely randomized worlds, procedurally generated games can't, by definition, have author-created stories. The game designer can't predict your experience, so a standard game narrative doesn't work. Norton had to devise a different way to give the game structure.

"*Malevolence* does have a narrative, but naturally, it couldn't have an infinite written narrative. I would have had to hire someone forever to keep creating content!" Norton said. "So I experimented with interlinking the players."

Malevolence explains its world in an introductory scenario, but it doesn't have a prewritten story beyond that. The game is set in a dream world created by a sentient magical sword, and you play as the physical embodiment of that sword's will. In this scenario, every player is effectively the same character (the manifestation of the sword's will) exploring the same world (the dream of the sword) at the same time.

Players don't meet each other, but they share a universe, and their actions impact other players' games. When you enter a dungeon, a notice tells you the name of the first character who entered that dungeon, and if one player's character dies, other players find that person's body in their world. Players can also drive their weapons into special stones for other players to pull out, a mechanic that borrows from the Arthurian legend of Excalibur.

These elements allow *Malevolence* players to write their own legends, and fan events have even become part of the game's lore.

Opposite and following page: Concept art from Malevolence: The Sword of Ahkranox *(Carrie Oglesby)*

Norton said, "There was a player-organized tournament where participants decided to all start at the doors to the same dungeon and try to get to the bottom of it. Of course, there was a clear winner, but that's not the really interesting bit. The guy who got to the end found an amazing sword, and everybody wanted it. It actually became a legendary weapon in the game's fiction on our forums!

"It was famous not because a writer making the game decided it would be, but because of the actions that players took in the game. It had a real story, and everyone watched it become a famous blade. And it's still being passed around in the game."

While it's fascinating to watch players write the fiction of *Malevolence*, Norton also

Concept art from Malevolence: The Sword of Ahkranox (Mihaela Epuran)

realized that this community-based storytelling wouldn't be immediately accessible to new players, especially if they didn't want to join the forums. So he released an expansion pack with a predefined narrative arc.

"The expansion pack has a story with a proper ending. It gives a purpose to your existence in *Malevolence*, which the base game doesn't really have," he said.

And whether you choose to create your own purpose in *Malevolence* or let the game provide one for you, your tale only ends when you want it to—just as Norton dreamed.

In-game art from Malevolence: The Sword of Ahkranox (Alex Norton)